AUTHENTIC
PORTRAITS

Searching for Soul, Significance, and Depth

CHRIS ORWIG

rockynook

AUTHENTIC PORTRAITS: SEARCHING FOR SOUL, SIGNIFICANCE, AND DEPTH

Chris Orwig
www.chrisorwig.com

Editor: Ted Waitt
Project manager: Lisa Brazieal
Marketing coordinator: Mercedes Murray
Layout and type: WolfsonDesign
Cover design and production: WolfsonDesign
Cover photographs: Chris Orwig
Indexer: James Minkin

ISBN: 978-1-68198-346-2
1st Edition (1st printing, November 2019)
© 2020 Chris Orwig
All photographs © Chris Orwig except for photograph of Abraham Lincoln in Chapter 2 by Alexander Gardner, 1865, Library of Congress, Prints and Photographs Division, LC-B812-9773-X; Orwig family portrait on page 392 (Chapter 31 opening image) by Cara Robbins; and back cover author photo by Tony Mac.

Rocky Nook Inc.
1010 B Street, Suite 350
San Rafael, CA 94901
USA

www.rockynook.com

Distributed in the UK and Europe by Publishers Group UK
Distributed in the U.S. and all other territories by Ingram Publisher Services

Library of Congress Control Number: 2018933972

This book is printed on acid-free paper.
Printed in Korea

For Kelly, my wife and best friend.

CONTENTS

PART 05
POSING, DIRECTING, AND CONNECTING 233

PART 01

THE FOUNDATION OF AUTHENTIC PORTRAITURE

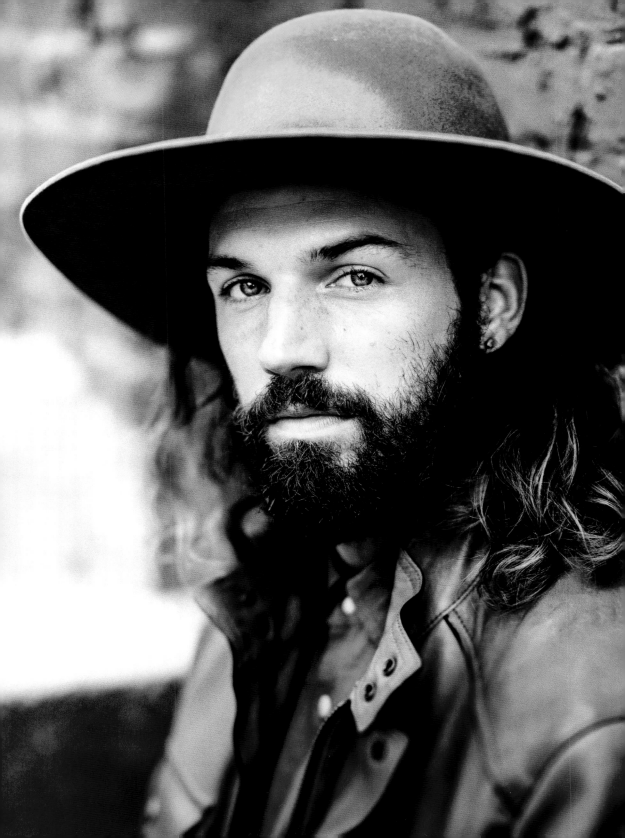

01

AUTHENTIC PORTRAITS

The purpose of art is to stop time.

—Bob Dylan

The most memorable portraits are simple, strong, and true. They convey personality, presence, emotion, values, and ideals. They awaken our senses and make us feel. They go beneath the surface and remind us what it means to be alive. In short, they are authentic and real.

THIS IS authentic portraiture. And this type of portraiture is just as much about you, the photographer, as it is about the subject. It's about having your own vision and voice for capturing and conveying the inner essence of who someone really is.

In *Authentic Portraits*, we are going to explore how this is done. Whether you are new to portraiture or you just want to add this skill set to an already flourishing craft, I hope this book is a helpful guide. It won't provide all the answers, but it will help you ask the right questions, and it will make you want to take the journey yourself.

Before we begin, a word of wisdom. Photography is among the easiest of art forms to practice, but one of the hardest to achieve your own unique vision, voice, and style. Taking a photograph is easy, but making a meaningful portrait requires a broad set of skills. And authentic portraiture isn't something you *master* but something you *pursue*. Kind of like healthy eating and fitness—it's a lifelong pursuit rather than something you do once and cross of the list.

And a significant part of capturing better and more authentic portraits is learning how to become more authentic yourself. Becoming your true, unfiltered, and best self is no easy task; that's why so many books, seminars, and conferences address the topic. Plus, becoming more authentic is connected to improving almost every aspect of life—and so it's relevant to anyone who wants to live a more amplified life.

Yet, as photographers, we have a multifaceted need for authenticity. We need to be our best, authentic selves while we ask others to do the same. Because photography is a craft, this can be quite a challenge. Clearly, learning the fundamental techniques of exposure, focus, and composition is essential, but authentic portraits aren't made by cameras alone. They're the result of the collaboration and connection between the parties involved.

COLLABORATION AND MYSTERY

Every good portrait is a collaboration between the subject and the photographer. The photographer must learn not only how to use her equipment well, but how to see and how to be—how to be present, mindful, open, trustworthy, inquisitive, curious, and kind. The portrait photographer must also learn how to look past the surface and search for hidden truths.

Portrait photography is about the active search for the magnificent in the mundane, and it's about searching intently for beauty, strength, and depth. Most of all, authentic portraiture is about capturing the inner essence and infinite spirit within us all.

So when I capture a portrait, I look for what can't easily be seen: I search for inner strength, silence, and soul. I hope to find hidden beauty, tenacity, or resolve. I want to find the person and personality under the facade. I aim to discover something that is real, whether that's fun, funny, wistful, or wise.

All the while, it's helpful to ask, "How can I craft and convey the inner story of who this person is?" While we search for this inner narrative, we also must consider light, space, place, color, and style. When all these elements converge, time slows down in a sacred way. In these moments, the rest of the world fades and I press the shutter release with a heart full of hope. Hope that the camera captures what I feel. Hope that the resulting image honors the person standing before my lens.

Capturing portraits this way requires a combination of observation, aspiration, serendipity, and skill. That's why it takes time to cultivate this craft. What looks nonchalant is more calculated than it seems. You must work with discipline, focus, and drive, yet at the same time be open to the fact that portraiture is less about perfection and more about letting the magic unfold.

Portraiture is a mysterious and unpredictable craft. The best portraits deepen this mystery rather than solve it away. As I'll discuss later, great portraits ask more questions than they provide answers. Those are the portraits that truly succeed. The portraits that fail often do so not because they say too little but because they say too much about all the wrong things—like clothes, hair, and looks, or light, shape, and form.

Making successful portraits requires balancing the externals (light, directing, clothes, looks) and the inner narrative of the subject (personality, identity, essence, soul). If one element is out of balance, it can tip the scale—a huge and exaggerated grin can ruin the entire frame, while a slight smile might add intrigue. With this balancing concept in mind, portrait photographers can learn much from other creative fields, especially those that strive to explore the inner landscape of life with artistic tact and skill. For example, let's look at how acting can inform the way we make portraits.

TIME SLOWS DOWN IN A SACRED WAY.

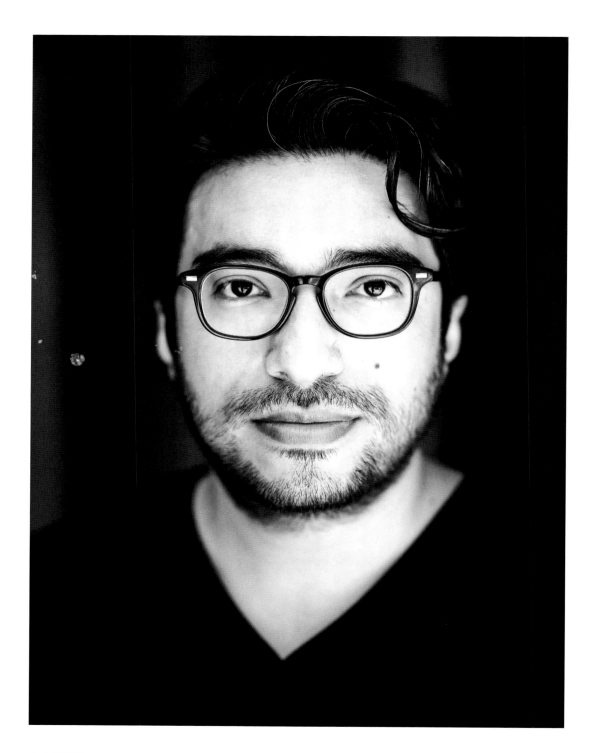

LOOKING DEEPLY

The legendary actor Dustin Hoffman gives this advice to young and aspiring actors: "Never practice your lines in front of a mirror!" He protests against reducing the art of acting to how it looks. Hoffman argues, "Acting isn't what you say or what you look like, but what you feel." It's not what we see on the outside but what wells up from within.

So it is with portraiture. Visual appearance matters, but the true aim of a portrait isn't looks; it's the human spirit within. The portrait artist who learns how to find that inner wellspring of abundance will go far because of how they connect, how they create, and how they learn and grow. That growth will be reflected in their frames.

Meanwhile, the photographer who continues to capture only the surface will stagnate and wonder why their photographs aren't getting better over time. Plus, once you get out of the habit of looking deeply, the visual interest of the outside world begins to dominate your view, and you forget how to truly observe and connect. This book aims to reverse that trend.

The good news is that what we have forgotten or lost can be quickly regained. When it comes to rekindling our sensory and observational skills, it helps to first look within ourselves to get the juices flowing, and then to look to our subjects. This idea of looking within isn't just good form; it's essential if we want to create something more than shallow frames. And while we must search deeply, we need to display what we find with a light touch so that our frames aren't filled with the tension and heaviness that comes from trying too hard.

UNCONTRIVED

Mitch, a theater professor and friend, puts it this way: "When you act, you must feel at 100%, but give at 80%. Otherwise the inner emotion, expression, or idea will feel overdone." While we must dig deep, we must also take pains to make it look uncontrived. We must create photographs that convey emotion, but do so without the appearance of being overly emotional. We must express the soul without falling into the trap of using cliches, exaggerated gestures, or mystical light.

Ultimately, we do this by striving for authenticity.

As you're starting to see, this is a book about portraiture but also about you—life and photography are inextricably intertwined. Like a tree and its roots. So this book is about how to use a camera, how to engage with subjects, and how to expose properly—and it's also about how to think, how to work, and how to become a better version of yourself. Because who we are has the largest impact on what we create.

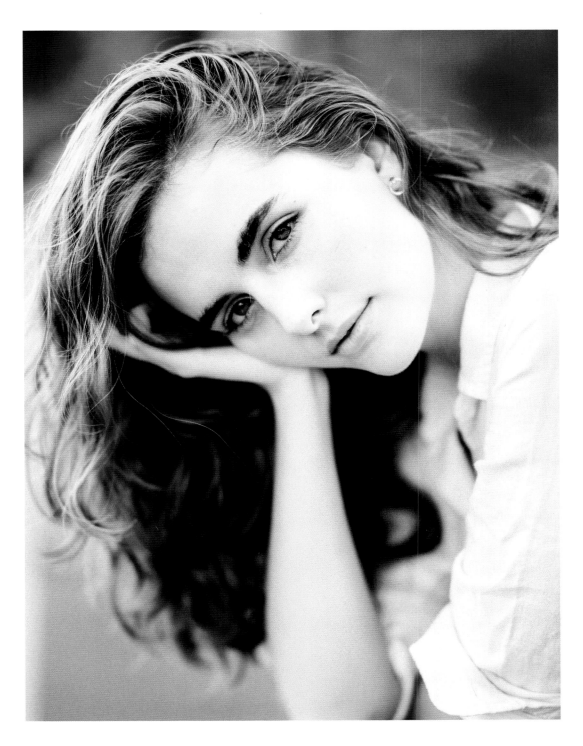

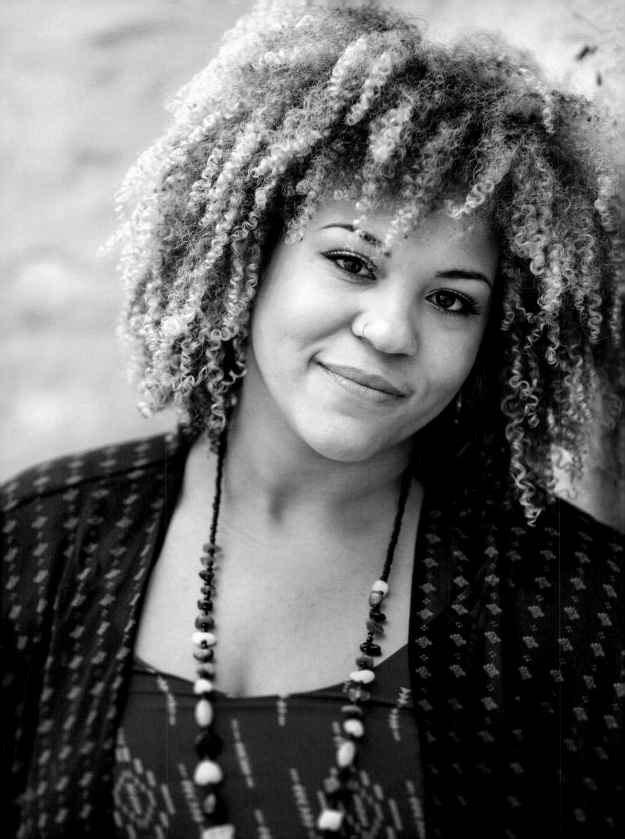

02

BENEATH THE SURFACE

To be human is to look so closely and
so deeply into another that you see yourself.

—Travis Blue

Have you ever noticed that great portraits somehow shine with an inner light that shows us the inner essence of who someone is? And have you seen how these portraits convey not just "looks" but personality, personhood, and soul? Great portraits hold our gaze as they invite us to reflect and to ask, "Who, what, and why?" And that inquiry reminds us that we, too, have an inner landscape obscured from ordinary sight. What we see in a great portrait isn't just a portrait of someone else, but something that reflects back as well.

WHEN LOOKING at a portrait—whether that be Abraham Lincoln or a painter standing on the beach—what we see first is the depiction of someone else. Then we look closer and see the qualities of who they are. Closer still, and we see a reflection back—something that creates an emotional impact. Perhaps we see what we admire or maybe what we fear. Mostly we see qualities to which we can relate.

Take, for example, a portrait of Lincoln. In almost every portrait of him, we first see the icon and great man. Next, we notice his high cheekbones, gaunt face, and messy hair. Then we observe his suit and crooked bow tie. We start to see his stature, dignity, resolve, and fatigue. If we look long enough, we start to see the human that he was. Not a bulletproof superhero but someone with a heart and with unfulfilled dreams. We see his faults, flaws, and personality. Finally, we see someone who is unquestionably unique.

In all their specificity, great portraits remind us that we are specific, too—no one ever has been or ever will be just like us. And herein lies one of the many beautiful paradoxes that portraiture relays—we are all unique, but we are all the same. The best portraits embrace and embody this truth. They possess and project an electric connection between the universal and the specific that gives them an energy of their own.

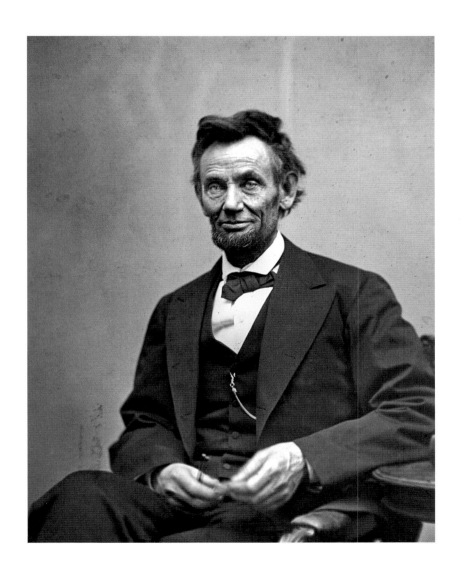

03

THE PARADOX
OF PORTRAITURE

Mysteries abound where most we seek for answers.

—Ray Bradbury

Authentic portraiture hinges on what, at least at first glance, seems like a contradiction: A good portrait is about who someone is and not what they look like, yet the only way to reveal the subject's essence is through what we see and how they look.

ADDITIONALLY, how someone looks often hides or disguises what lies within— we all wear social armor to protect our inner self, and rightly so, as it's the only way to survive. So much depends on how we look, from first impressions and job interviews to dating and whether or not we trust someone. That's why capturing authenticity is incredibly difficult and, if we're being honest, probably impossible to achieve. But authentic portraiture isn't about creating a perfect portrait; it's about striving to capture something that is more real than fake. And the same thing is true in life: we strive for authenticity even though it's always out of reach.

The reason we put so much effort into authenticity and, at the same time, admit it is an unreachable goal is because this paradox is what makes us real. When we honestly accept and admit, even to a small degree, inauthenticity, we become authentic ourselves. In a strange twist, it's the acceptance and admission of the impossible that allows authenticity to take on its truest form.

Still, the attempt to capture authenticity is incredibly hard. Even harder is being your true and authentic yourself. As Ralph Waldo Emerson famously put it, "To be yourself in a world that is constantly trying to make you something else is the greatest accomplishment." We all know it's hard to be our true self, but sometimes we forget that same challenge applies to our subjects, too. We forget what it's like to be on the other side of the lens, to have someone else evaluate themselves while we wield a camera that captures every "flaw." So part of our job as portrait photographers is to encourage and support that subject in their journey of being him- or herself.

The quote by Emerson sums up so much of human experience, and it raises questions, too, such as, "What does it mean to be yourself and why does the 'world' make that so hard?" Emerson reminds us that being true doesn't come from following the crowd. It comes from relying on that inner light rather than the blaze from the crowd. And as faint as it might be, the spark within is always more trustworthy than the warm glow from the crowd.

According to some psychological typology tests, I'm a mix of an introvert and extrovert but I tip the scale more toward introversion. What this means in practical terms is that I have my best moments away from the crowds. I come up with my best ideas while I'm on a solo bike ride on the mountain behind my home. At parties, I enjoy one-on-one conversations more than

talking with a group. And I have created most of my favorite photographs when there weren't a lot of people around. Knowing this about myself, I almost always keep my photo shoots simple and small. Ninety percent of the time, it's natural light and one on one. No assistants, no lights, no hype. That's the way I like to work because it frees me up to be myself. If I can be a truer version of myself, I know that can help the people around me find and access their inner truth as well.

Take a moment to think about your own personality type and the environment that helps you become the truest version of yourself. Then pursue portraiture with that in mind.

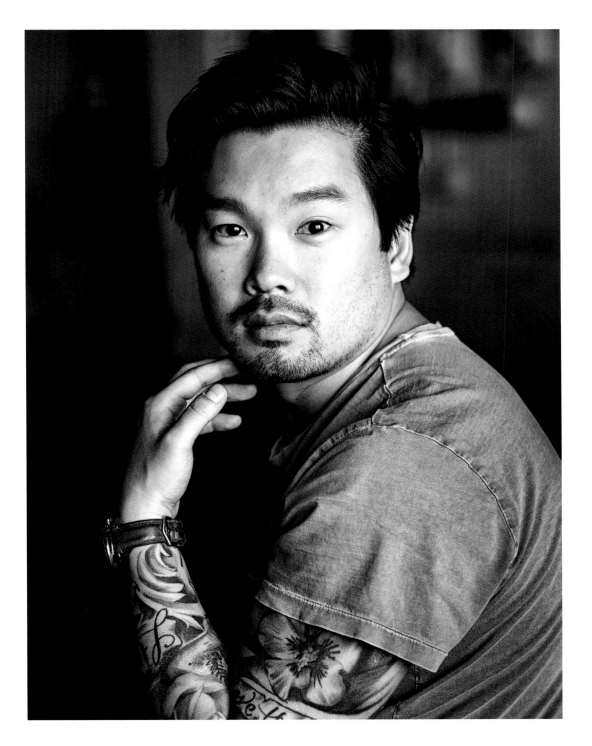

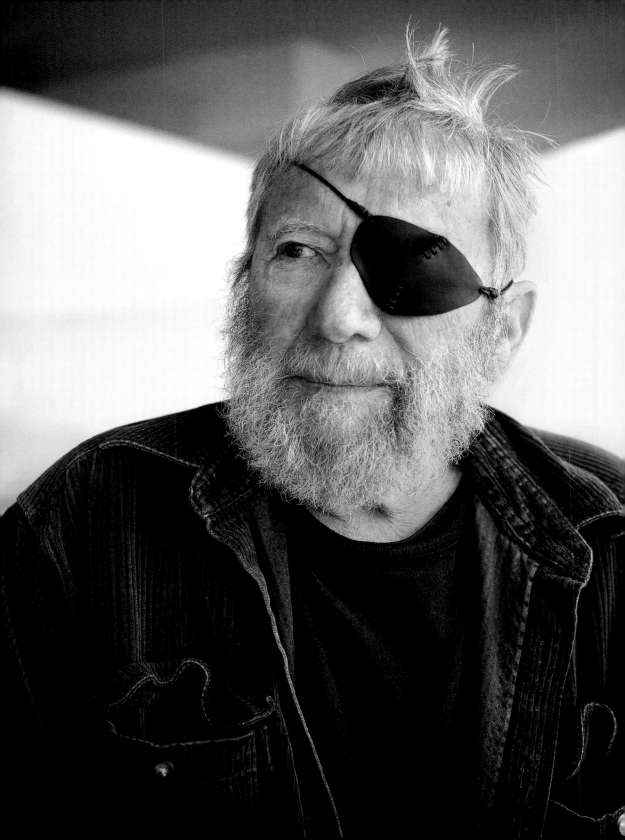

06

THE SEARCH

Watch with glittering eyes the whole world around you
because the greatest secrets are always hidden
in the most unlikely places.

—Roald Dahl

Answers are easy, questions are hard. Answers boast and shout out loud.
They like to show off as they shimmer and shine. Questions, on the other
hand, lead, provoke, wrestle, suggest, and inspire. They work quietly, like a
needle and some thread.

AS PHOTOGRAPHY

students, we tend to gravitate toward the easy answers—at least that's what I do. I say, "Give me the gear, lighting setup, posing rules, ideal f/stop, and I'll be on my way." But making photographs that way is the equivalent of a science student copying down the answers from someone else's test. And while copycat answers may temporarily help, they cut out any opportunity for real growth.

True growth happens when we find an answer on our own. Yet even then, a newfound answer can seem so obvious, at least once it's been found. Like a nugget of gold found on a pebble-covered beach. The gold is placed in a glass jar. Later, back at the beach house, seeing the gold glitter in the jar makes it seem that answers abound. But in truth, they are difficult to find, which is why they're so celebrated in articles, blogs, and books. But I've always found that books full of answers are a bit dry. I prefer books and teachers that get me to think.

So in this book, I've included some answers, but spent more time sharing ideas and raising questions that will help you to grow. And as you flip through these pages, you'll notice that I'm not trying to show you how to capture the perfect portrait, but how to make a portrait that draws the viewer in. Like in my own portraits, I hope you notice that they aren't perfectly resolved. Rather, each portrait invites you to take a moment to pause.

What makes a portrait good? What is authenticity? What is soul? How can we improve our craft?

Questions like these have ignited my own search. By writing them down, I've come to realize I've been pursuing them for a long time. But for the first half of my life, I didn't quite have the words. I knew I was looking for something, but I wasn't sure what. Now, as I reflect back, I recognize that I've been pursuing questions about meaning, substance, and depth my whole life.

These questions have been woven through so many aspects of my life: friendships, faith, photography, athletics, adventure, identity, art, music, literature, and career. Through it all, I think the overarching question has been, "Shallow or deep?" And I was asking this question with a curiosity and inquisitiveness that opened doors. People like questions when they are asked with the right intent.

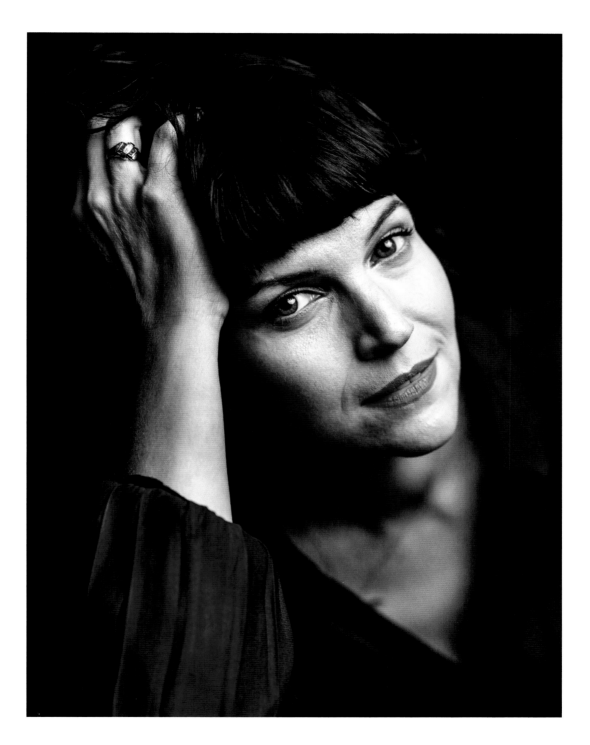

CURIOUS QUESTIONS

As a kid I asked my Dad how a TV worked. He set our broken TV on the work bench and handed me some tools. As a teen I asked a friend what surfing was like. He took me to the beach. As a college student I asked my brother about Europe. He convinced me to study abroad. As a young teacher I asked one of my students how to use a 4x5 camera. His instruction catapulted my career. And now, every time I photograph someone I ask lots of questions. I don't ask in an overbearing way but with a simple sincerity. The questions help the subject open up and provide me with insight into how to craft my frames.

Questions and portraiture go hand in hand. They are connected in such a direct way that I can confidently say you can't capture a decent portrait without some form of inquiry. And the better the questions, the stronger the frame. Later in the book I'll provide some sample questions you might ask. For now, simply recognize that being curious and asking questions is key. It's one of the quickest ways to improve your craft.

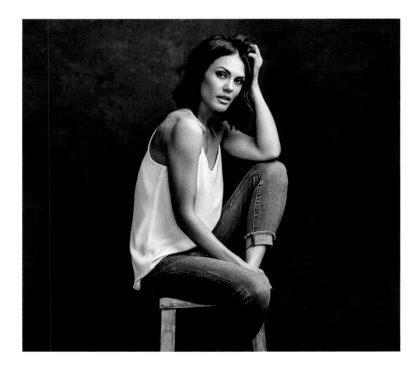

AN UNLIKELY FRIEND

Through decades of asking questions, I have found a few solid answers but mostly I've learned that life is always more than it seems. Everywhere I turn, I discover this truth. People are more than their jobs; religion is more than the rules; and being a photographer is more than using a camera and lens.

And Eva was more than a middle-aged cancer patient waiting in Room 9.

Visiting Eva was part of my job. As a graduate student, I fulfilled my practicum requirement for volunteer work at a nearby hospital. My job was to visit and talk with patients. Looking over my clipboard one day, I saw Eva's name on my list. She was on Floor 3 in Room 9. On paper, she was a name, age, gender, race, and cancer type. How could I have known that she would become my mentor, teacher, and friend?

I visited Eva for a few months. I began each visit with the question, "How are you doing?" She would respond with a question of her own: "Do you really want to know?" "Of course," I would say with a smile. She always liked to talk in a candid and honest way. I listened and learned about her family, friends, sorrows, upbringing, pain, faith, and fears. As Eva's cancer worsened, she opened up more. As she faced her own death, she continued to share.

During this time, I was going through some worsening health issues of my own. I spoke with her about my own pain and she understood. She encouraged and helped me to be brave and to "fight the good fight," as she used to say.

When she died, I lost a mentor and true friend. When I think about her now, I am deeply grateful for all that she shared. She taught me to savor small moments and to love with an open and non-judgmental heart. She taught me to look deep into life and to pursue the light. She taught me that life, and even death, are so much more than they seem. In short, she taught me how to live, how to love, and how to let go.

At the same time that Eva was dying, I picked up a real camera for the first time. While she and I never talked about photography, I consider Eva to be the first and best photography teacher I ever had. Because Eva and I talked about life, death, hope, and loss. We talked about savoring life intensely. In many ways, as a photographer, that is all I do. It's really simple when you boil it down.

Maybe you have your own "Eva" who has taught you about what is most important in life. And in doing so has taught you how to capture better frames. Never overlook or underestimate teachers like this. And even though you never met Eva, I think she has a valuable message for us all. As photographers, we have to remember that every person is always more than they seem. Our calling as portrait photographers is to find the story within.

The next time you do a portrait shoot, look at your subject with an open heart. And rather than telling your subject how to stand or act, ask them questions and see where it leads. Search for the story within, and search for the message you might need to hear.

08

INVISIBLE LIGHT

What is essential is invisible to the eye.

—Antoine de Saint-Exupéry

There is a spectrum and quality of light the eye cannot see. This is the light that the soul senses, detects, and knows. It's the light that shines from a bride walking down the aisle. It's the light that emanates from a young child who just got a new bike. It's the keen brightness of an enlightened mind. It's the light that fills you with warmth when you reconnect with a long lost friend. It's the glow of gratitude on the face of a kid who finally found her lost dog. It's the soft light of acceptance on the face of an old man who faces death and smiles at his family for the last time.

This kind of light is ancient, powerful, and divine.

THROUGHOUT HISTORY,

painters, poets, leaders, and common folk have struggled to describe it. It's the kind of light that cannot be empirically measured or visibly seen. It's more like a power, presence, or knowing. Here's how Gandhi described it: "There is an indefinable mysterious power that pervades everything. I feel it though I do not see it. It is this unseen power which makes itself felt and yet defies all proof."

It's not just Gandhi. Most of the major faiths describe the invisible and mysterious power as the divine. Most often, the faith groups use the metaphor of light—God is light. While these faith groups disagree on so much, light is the commonality shared by all. Across the globe, God and light go hand in hand. And so when we see that light shining from the bride, the young child, or the old man, I like to think that we are really seeing the substance of God, or at least some kind of divine light that connects us all.

THIN PLACES

In most faith traditions, this divine light shines through our good deeds and acts of grace and love. But it also shines through other things (animals, plants, trees), activities (music, art, dance), and places. The ancient Celts in Ireland had a great way of talking about the connection between divine light and place. Celtic mythology defined the separation of heaven and earth as "only three feet apart" but saw some places as "thin," where the distance was even closer. Thin places were often wild landscapes, mountaintops, or where a river met the sea. What made a place thin wasn't so much the geography but the experience there. The poet Sharlande Sledge explained, "Thin places are where the door between this world and the next is cracked open for a moment, and the light is not all on the other side." A "thin place" wasn't so much about what you saw, but about what you felt.

This Celtic notion of a "thin place" gives us words to describe the experiences we have in such majestic landscapes. When I'm out in the wild, I often feel small and am brimming over with a sense of awe. It's the same kind of feeling I had when I saw my bride walk down the aisle, or watched the old man smile at his family for the last time. There is no other way to describe these moments except as a feeling of awe, wonder, mystery, and light. As I reflect on these experiences, I realize that as I was caught up in that moment, nothing else mattered—bills didn't matter, time didn't matter, I didn't matter. My ego disappeared.

I once heard someone say that being selfless isn't thinking less of yourself, but thinking of yourself less. And it's in those moments of divine light where that happens most for me. I've come to realize that this is one of the main reasons I capture portraits: being filled with light helps my ego disappear. In more practical terms, working with a camera and connecting with another soul helps me stop obsessing and worrying about myself. The camera helps me feel small in the most beautiful way; it figuratively and literally takes the focus off me. In that moment, I lose myself and all I know is light. And that light restores and recalibrates my sense of truth, purpose, and joy. In a way, I take photographs in order to shed the excess baggage of having an overinflated sense of self. And I also take photographs to heal. With camera in hand, when I see someone else in a truly authentic and genuine way, their authenticity helps me bring forth my own.

Just as the Celts describe landscapes, mountaintops, and rivers as "thin," I'd like to call portrait sessions the same. When a connection is made with camera in hand, it becomes a moment when that light shines through from the other side.

INCREASING YOUR INNER LIGHT

But what do you do if portrait photography seems like it's the opposite of this mystical Celtic idea? What if portraiture feels awkward or intimidating, or it makes you nervous? First, know that you are not alone. I feel this way almost every time before a shoot. My strategy to combat this anxiety comes from insight from my yogi friends.

These friends remind me of the importance of preparing myself. For them, the quality of a yoga session has less to do with the teacher, movement, or pose than with their own internal state. To get to a better state, I think about one of yoga's most popular terms: *namaste*. This is a word spoken at the end of a yoga session. The instructor puts her hands together, bows, and says, "Namaste," and the students return the gesture and phrase. What does namaste mean? While there are countless definitions and nuances to the term, my favorite is the one related to light: "The light in me recognizes the light in you."

This idea of "light in me seeing light in you" is truly one of the great secrets to capturing better portraits. We must first look within, and only then can we see. We have to prepare ourselves if we want to experience change. Visiting a so-called "thin" place won't work its magic if you aren't open to it or in the right state of mind. It's kind of like going to Yosemite and staring at your cell phone the whole time. Doing this inhibits the effect of Yosemite that John Muir once described like this: "Climb the mountains and get their good tidings. Nature's peace will flow into you as sunshine flows into trees." If we open our eyes, pause to sit down, and breathe deeply, the mountains and all their goodness will take effect.

So we first have to cultivate an inner light for it to begin to show up in our frames. What does it mean to cultivate your own inner light? Do you need to practice yoga, burn incense, or go on a mystical retreat? It surely wouldn't hurt, but there is more than one path. For me, cultivating the inner light can be as simple as taking time to slow down, whether that's by reading a book or going for a walk and leaving my phone behind. Other activities that bring clarity to my life are meditation, exercise, journaling, and doing something kind for a friend.

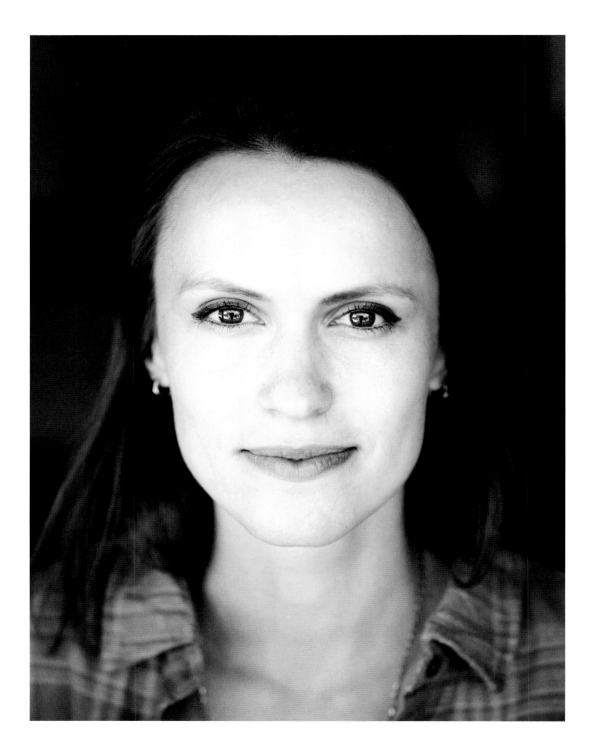

You'll have to figure out what it is for you, but don't neglect doing this. It will absolutely change how your portraits look and feel. Even though no one usually teaches this stuff in photography school, workshops, or books, trust me; it works. Try it for yourself and you'll start to see a new kind of light filling up your frames.

And if you really want your portraits to shine, dig deep and do more than take a long walk or go to the spa. You might need to do some deep soul work. For me, this most often means facing and tending to my wounds. For example, a few months ago I was stuck in a rut. I felt hollow, lonely, and down. My portraiture reflected this void. Eventually, I lost all interest in taking pictures. I couldn't figure out what was going on, and I could not get myself unstuck. I journaled, talked with friends, and read books, but nothing seemed to help.

Finally, I went on a trip to New York and something clicked. As I walked the streets of New York, the people and the energy there made me realize I was harboring disappointment, self-pity, and sadness from how my job situation had recently changed (long story short: my income from online tutorials dried up and I was angry and felt sorry for myself and feared what the future held). The fear, self-pity, and sadness were undercurrents I hadn't yet admitted to myself. It was on this trip that I accepted the feelings and, in turn, accepted myself. I told myself that the emotions were valid, that feeling down was an acceptable response, and that I needed to reach for help. As I began the process of facing these wounds, I realized that the roots were deep; they went straight to my core. The real issue had less to do with income or work and more to do with ego, identity, and unresolved fears that I had been trying to ignore.

So rather than beating myself up, I sought healing and squared off with those issues with healthy doses of kindness and grace. Through the process of journaling, talking with colleagues, and bringing it up in therapy, my interest in portraiture came back. It was like I needed to do some soul work before I could reenter the game.

As I started capturing portraits again, I noticed that they looked and felt different. As I shot more photographs, I began to heal even more, and a new kind of light began to shine—a light that was vulnerable, honest, and true. Not only did I like the photos more, but they resonated with others more, as well. Nothing had changed with my gear, light, or approach. The only difference was what was going on inside.

Realizing this, I revisited those wonderful words by the poet Rumi: "The wound is the place where the light enters you." And I listened again to Leonard Cohen's lyrics: "There are cracks in everything. That's how the light gets in." Yes! This was music I needed to hear. The point wasn't to hide or be ashamed of my own faults but to embrace them in an honest way. I had found the answer to Thoreau's question, "How does the light get into the soul?" It's through the cracks, imperfections, and wounds.

When we face our wounds with kindness and care, it makes us more human and real, and it helps us to see others in the same way. Again, namaste: the light in me recognizes the light in you. And although I can't literally see you right now, I imagine you reading this book and I see a bright light shining within your soul. It's a bright, warm, and wonderful light that the world desperately needs. So do whatever soul work you need to do, so that we can benefit from the light that you shine.

The reward of all this, as you're starting to see, isn't just photographs that everyone likes; it's that your life becomes fuller and more alive. When we approach portraiture with honesty, kindness, and grace, it has the potential to enrich and even heal our lives and the lives of those we come in contact with. So in this way, portraiture becomes more than pictures. It becomes a way that we all move ahead.

THE POINT WASN'T TO HIDE OR BE ASHAMED OF MY OWN FAULTS BUT TO EMBRACE THEM IN AN HONEST WAY.

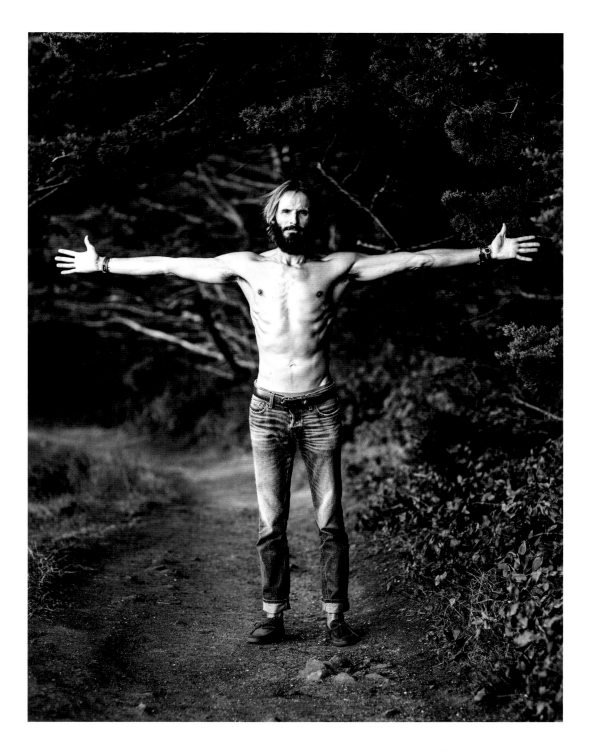

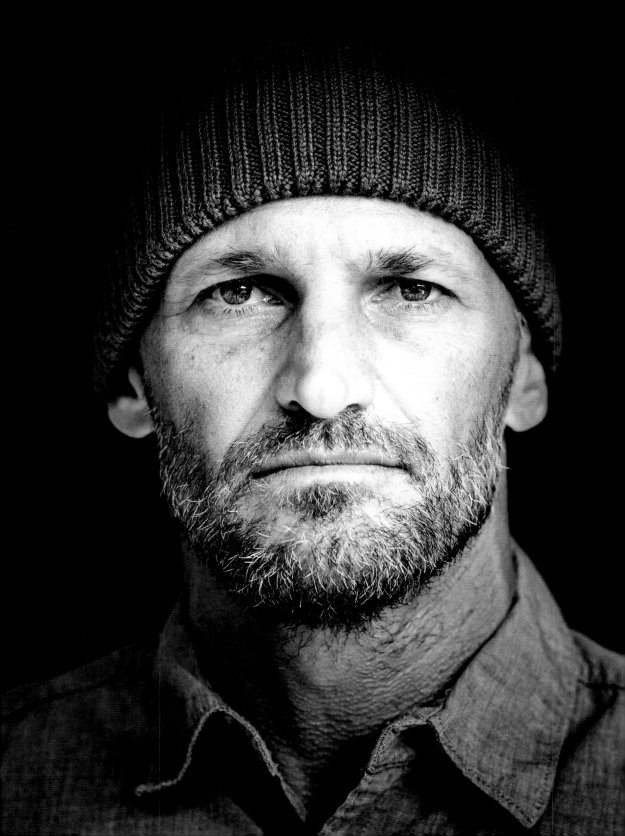

09

DEFINING AND CULTIVATING SOUL

We do not see things as they are, we see them as we are.

—Anaïs Nin

The world does not need more "perfect" portraits. The world needs portraits with significance, depth, and soul. The trouble is, we don't really know what soul is or how to take aim. Because the word *soul* is nebulous, and striving for soul can feel like shooting an arrow into the clouds. There is no way to know if you hit your mark. And there is no one definition or description that sums up the word. But we can still try to develop a fundamental understanding of soul so that we can at least strive. With that in mind, let's begin with a common phrase that describes (in non-scientific terms) what humans are made of: heart, mind, and soul.

These three words are used as a trinity to describe what lies within.

OF THESE THREE words, soul is the most difficult to visualize. Anyone

can draw a Valentine's Day heart, and if you put in some effort you could draw the mind or brain, but the soul has no distinct graphic shape or form. And so it goes mostly unknown and unseen. Maybe that's because the soul resides deep within and often likes to hide—kind of like the owl that lives in our backyard.

A few months ago I hung an owl box in the tree behind my cabin/office, hoping to attract an owl. The little rectangular owl house is made of wood, with a circular opening at the front. Inside it is divided into two halves so that the daylight doesn't disturb the owl while it sleeps. My family and I waited for a long time for an owl to move in, and finally, just a few weeks ago, we caught our first glance. As the sun began to set, I ran inside to get my kids and we all tiptoed up to the giant oak tree. With wide eyes we watched silently as a beautiful owl peered out from its new home. Since then, at dawn and dusk I go back to that tree and watch the owl—that's the only time it's at the opening of the box. At night as I go to sleep, I listen for its harmonic song.

The soul is like that owl nestled in the box. If we are too noisy or get too close and seem to pose a threat, it won't come out. But when the conditions are right, it surfaces into view. If I wait and watch patiently, I'm rewarded with a beautiful moment. The same is true for portrait photography.

When I first started capturing portraits, my focus was on gear, exposure, and light. But the longer I pursued the craft, the more fascinated I became with the idea of soul. I searched for the word soul in books, blogs, movies, and everyday life. I started paying attention to when and where I heard it most.

This pursuit led me to consider previously ignored cliches: "good for your soul," "soul searching," "bare your soul," "don't tell a soul," "sell your soul," "there wasn't another soul for miles." Compare these phrases without using the word soul: "good for you," "searching your self," "bare your thoughts," "don't tell anyone," "sell your personality," "there wasn't another person for miles."

When the word soul is employed, it suggests something more—more interesting, more profound, more unique. A soulmate is more than a spouse, an old soul is more than a deep thinker, and a lost soul is more than someone who just needs a map. Soul implies essence, wisdom, depth, power, significance, and so much more.

Certain religious traditions tell us that when we die the soul lives on. Other traditions suggest that the soul is the core of who we are. Some see the soul as our infinite and eternal spirit. Considering such philosophies and belief systems, it's no wonder the soul cannot be easily described.

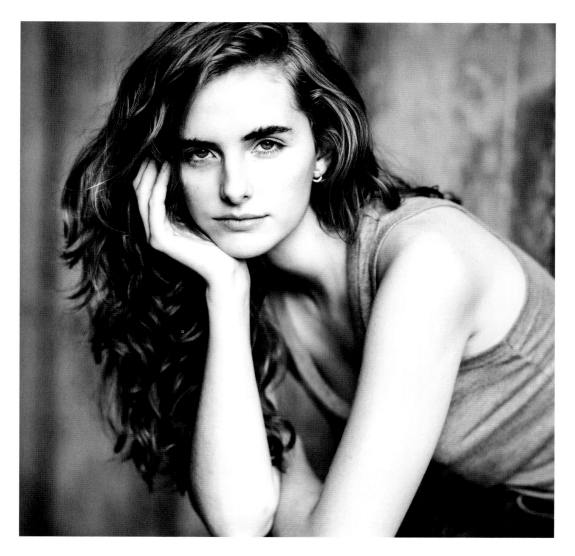

SOUL SEARCHING

Even though the soul can be difficult to understand and even more difficult to find, since the beginning of photography, portrait photographers have been looking deeply into the eyes of their subjects, waiting for the soul to surface into view. If the eyes are the window to the soul, then the metaphor suggests that these windows can be covered, blocked, or closed. That's why the soul doesn't appear in every frame. Connecting with another person is a gift, and it doesn't happen without being soulful yourself.

One way to search for the soul in others is to cultivate a soulful depth in yourself. Soulful connections seem to happen in a soul-to-soul kind of way. And like the little wild owl in my backyard, the soul seems to listen and look for clues before it surfaces into view. The soul's sensory input is even more primal and complex than the owl's. It functions at a deep level that includes the subconscious, heart, mind, and spirit.

The soul doesn't care what someone looks like, as looks can mislead. Nor is the soul distracted by imperfections, as the soul always understands that beauty, strength, and wisdom take on many different shapes and forms. But the soul does ask deep, mindful questions like, "Can I trust this person? Have they suffered? Do they have my best interest in mind?"

If we want to create portraits filled with soul, we have to begin to cultivate our own.

HANG THE BOX

How can you begin to cultivate your own soul? It begins with getting to know someone who can help, just like with my owl. My owl never would have moved in had I not talked with Adam. Adam is a botanist at a nearby garden called Lotusland—ranked as one of the ten best gardens in the world. Lotusland happens to be located two blocks from my house and across the street from my daughter's elementary school. Each year the kids take a field trip there and get a behind-the-scenes tour, and I always volunteer to chaperone. On one trip, I asked one of the docents about all the owl boxes up in the trees. She told me that if I wanted to learn more, I should call Adam, their resident owl expert.

Adam was very excited to tell me about all the research and experience he had with owls. Through a few phone calls we became friends, and he instructed me in everything I needed to know about the owl box and where to hang it. Thanks to him, we now have a beautiful owl that lives in our backyard. That owl keeps the rodent population in check and fills the night air with its beautiful call.

Yet, it all began with a few questions with someone in the know. That's how we cultivate the soul. We look, listen, and search for people who are skilled in the ways of the soul. Then we take the initiative to ask questions and search for any wisdom we can gain. But this is where most people stop. They look, listen, and learn...but then forget to act. If you want to attract an owl, you have to hang the box. This might mean developing a new practice or reading a new book. But whatever it is, do the work so that you can approach portraiture with more depth.

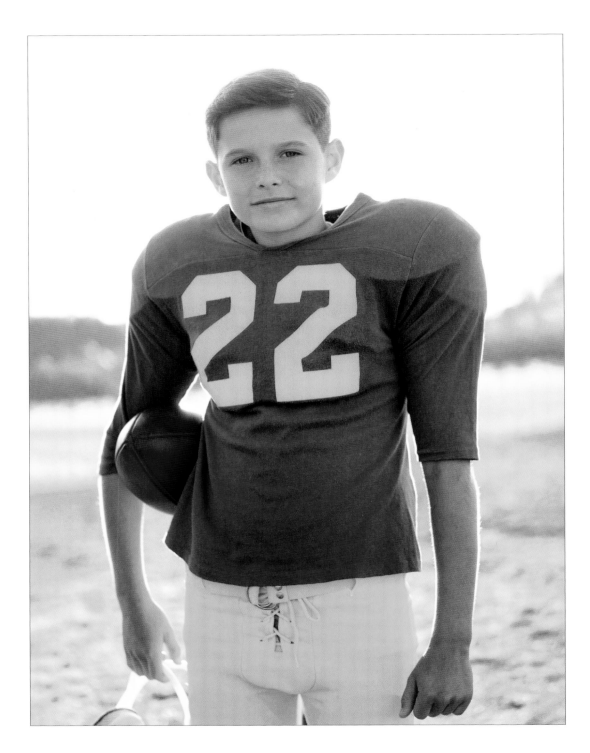

Mother Teresa once said, "God is a friend of silence." God, divinity, or the supernatural (however you define it) tends to value quiet, and so do those who pursue the divine. Many of the world's great monasteries, meditation centers, cathedrals, and temples create a sense of sanctuary by blocking out so much visual and auditory noise. So it makes sense that those who cultivate a sense of quiet see the world in a different way; maybe they even see the world with more God-like or spirit-filled eyes. The most spiritual people I know look at others and the world in a different way, and they see more. I think it's because the practice of silence helps to calm and quiet the noise that typically drowns out hidden truths.

Additionally, silence has a restorative effect. For me, it restores my senses so that I can see with more clarity and depth. As Sir William Penn put it, "True silence is the rest of the mind, and is to the spirit what sleep is to the body, nourishment and refreshment."

When I take time to practice silence, it's like putting on reading glasses: All the words become clear. And not only can I see more clearly, I can understand more. As I read—with clarity and with intention—I start to notice themes running through the plot like threads, and I discover hidden connections between characters that I hadn't seen before.

Because photography is so fast paced and complicated, many of us forget to take the time to read deeply and truly understand—it happens to me all the time. But learning how to see deeply requires that we quiet our over-productive minds.

Buddhist philosophy illuminates this idea of seeing deeply in a poetic way: "Learn to see the cloud in the tree." At first glance, this may seem like an esoteric phrase that doesn't mean much. But when we look closer, a connection forms—without the cloud, there is no rain, and without rain, the tree cannot grow. So the cloud and the tree are deeply connected. In the same way, the photographer who quiets her mind and sees deeply looks at a tree or a subject and sees more. Rather than a trunk, branches, and leaves, she sees roots, rain, rivers, sap, soil, streams, and clouds. Imagination, silence, and slowing down help her to see the hidden connections and stories that were always there, waiting to be found.

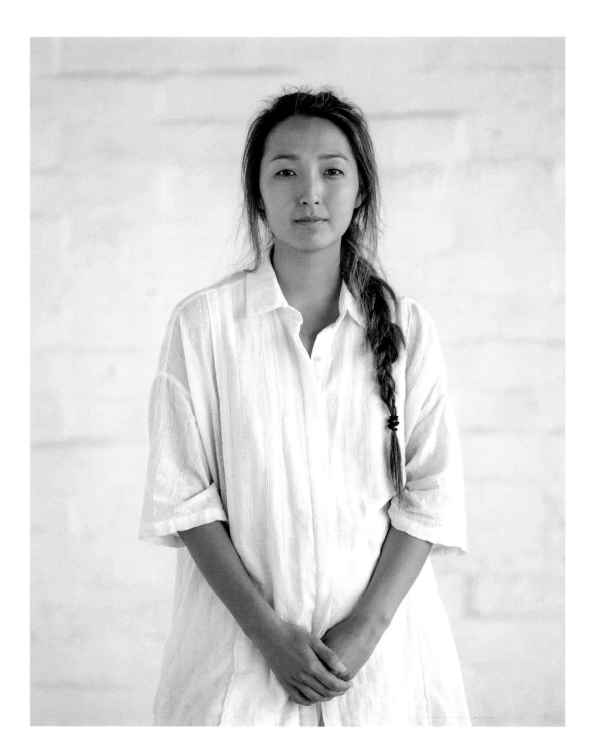

BRAINSTORMING

One technique I use in order to help me see in a quieter, deeper way is to brainstorm in a non-traditional manner. In general, brainstorming is a technique used to find solutions by thinking outside the box. It's most often used in corporate settings to generate bigger and better ideas. One of the "rules" of brainstorming is that there are "no bad ideas." Free from the constraints of getting it wrong, brainstorming has become a widely practiced technique for generating new and unorthodox ideas.

Generally speaking, brainstorming has been the domain of a Western approach to finding solutions for problems big and small. But what if brainstorming wasn't just about problems and solutions? What if it could help us to think about our portrait subjects with new insight and depth? For this kind of thinking, I like to blend the Western concept of brainstorming with some wisdom from the East—I think of this as "Buddhist brainstorming," and it's something I use in portraiture all the time.

Thich Nhat Hanh, the Buddhist teacher, writes, "True silence comes from the heart." This heart silence isn't just a monastic ideal but possibly essential to life. As he puts it, "We need silence, just as much as we need air, just as much as plants need light." So the first step in Buddhist brainstorming is to take a moment to pause and take a few breaths to calm your mind, regardless of what's going on or how many people are on a photo shoot. This first step helps me "detach" from my concerns and approach the shoot in a more open and honest way.

The second step is to ask yourself, "What is the cloud within the tree?" In other words, what is the story that I can't see at first glance? And so I ask myself creative questions like, "Compared to other things in life, what does that person look like? How do they stand? Are they more like a tall thin cypress or an old stout oak?" And I look for connections by asking questions such as, "Can I see the inner calm in his eyes that comes from overcoming pain or loss?" These are questions that I literally think to myself during a shoot. And the answers help me think with more texture and depth. The act of asking these questions is at the heart of Buddhist brainstorming. Do this and it will help you listen and look for the story within; instead of trying to "solve a problem," embrace the mystery that resides within us all.

Searching for the story within invites us to stop talking so much. This quieter approach can feel awkward because silence isn't "normal," especially on a portrait shoot. But it gets easier with practice and a little explanation so that your subject knows what's on your mind. Sometimes the easiest way to communicate this is to say something like, "Hey, I'm striving for a silent, simple, and strong portrait, so I'm trying to be quieter myself." And then ask a question like, "How has silence or the lack of silence impacted you?" Once you get them talking, you can look and listen with more intent. Then, eventually ask them to pause, and capture a portrait without anyone talking, as this can help you hear that whisper of truth within.

When I've had to step in front of the camera and have my portrait made, there is the usual chatter rattling around in my head. It sounds like this: "Does my hair look good? Am I standing the right way? Am I doing a good job?" But underneath those questions are deeper questions: "Do you see the true version of who I am? Do you see the unfinished song inside my soul? Do you see my dreams?" Ultimately, a good portrait photographer hears the unspoken questions, sees what can't be seen, and draws it out. And the only way to become that kind of photographer ourselves is to learn to be quiet and to look and listen in a deep and open way.

The Swiss philosopher Max Picard wrote in 1948, "Nothing has changed the nature of man so much as the loss of silence." It's true. We have changed. We no longer know and experience the luxury of silence like we used to. In our everyday lives, we're immersed in so much noise. We've become distracted. Or, as T. S. Eliot wrote, "Distracted from distraction by distraction."

But that's one of the reasons I love portraiture so much: The camera creates an occasion to have a quiet and sincere interaction, which enables us to connect with another in a deep and real way.

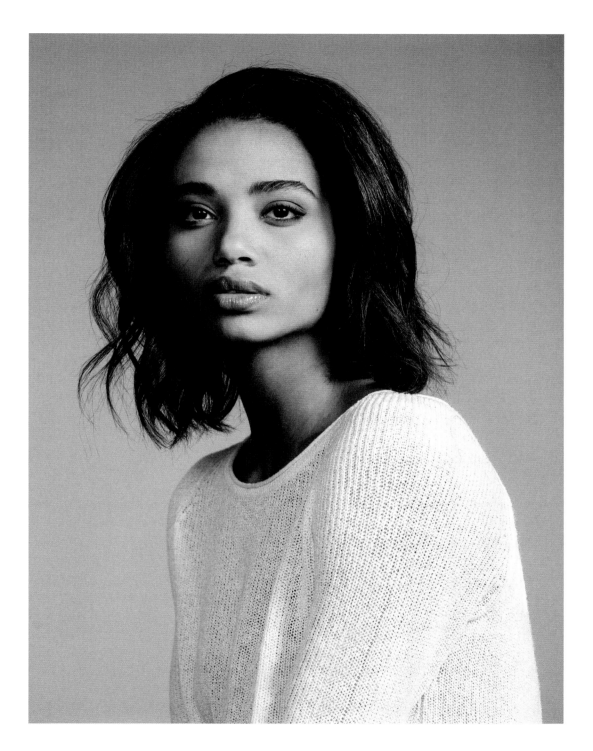

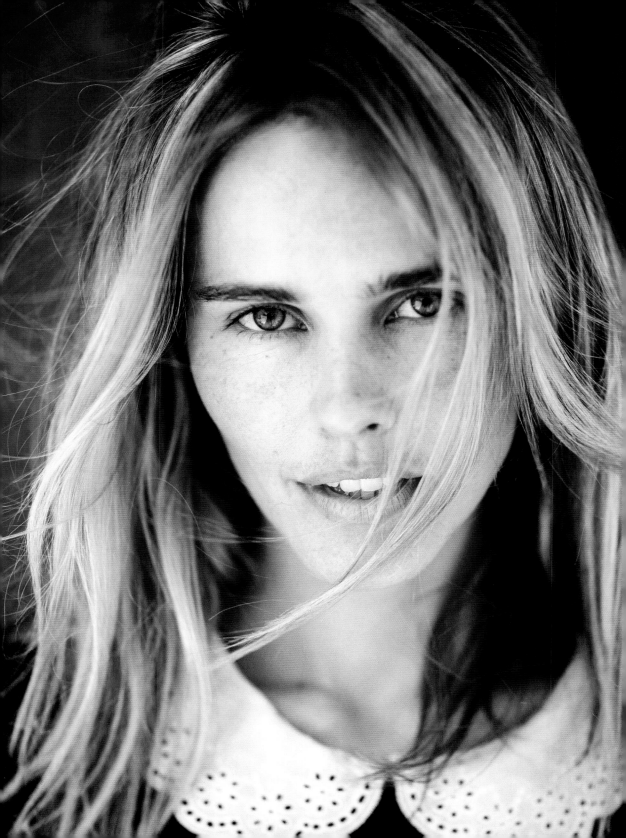

11
WABI SABI

To be beautiful means to be yourself.

—Thich Nhat Hanh

To be yourself is to be real. There's nothing more beautiful than that. But what does it mean to be "real"? Is real the version of yourself that shows up at work? Or is the real you something no one else ever sees and only you understand? Real is difficult to define.

MAYBE REAL is the wooden floor that's been hidden underneath the green shag rug of the hundred-year-old house a young couple just purchased. Buying the house and seeing its potential, the couple tears up the old carpet, and they ask themselves, "What should we do with the worn wood we have found?" Expediency urges them to cover it up so that it looks perfect once again. But an inner voice reminds them that the impatience of pergo provides a veneer that quickly loses its appeal. The quick fix always provides a satisfaction that doesn't last.

So they make the most with what they have. They pull out the rusty nails, sand, grind, repair, and seal the wood, and they do so with a gentle touch so that the true character and age of the wood remain.

This feeling, the one that old wooden floors provide, is what the Japanese call *wabi sabi*. Wabi sabi is an ancient Japanese philosophy that recognizes beauty and value in imperfect things. It regards patina and anything that bears the imprint of the passage of time with tenderness and respect. Wabi sabi celebrates cracks, crevices, and all the other marks that time leaves behind. It is simple, subtle, modest, and kind. Wabi sabi values what's unpretentious, earthy, and real. Wabi sabi is uncluttered and minimalist. It values history, narrative, and depth. And most of all, wabi sabi reveres authenticity in every way, shape, and form.

Wabi sabi is the reason we are drawn to places with deep history. Like the historic little Italian village, precariously perched above the Mediterranean Sea with its colorful chipping plaster walls, crooked cobblestone streets, unexpected wild flowers, and weathered fishing boats. It's one of the reasons we travel in search of people and places that counterbalance the newness of our freshly painted suburbs with their manicured lawns.

We acknowledge wabi sabi when we buy a handmade and imperfect ceramic mug. We embrace wabi sabi when we put on a record instead of turning on Spotify. We search for wabi sabi in antique stores and even manufacture distressed furnishings hoping they will have more soul. But true wabi sabi cannot be easily bought or made. It occurs naturally over time and is most often an unexpected gift.

WABI SABI IN PORTRAITURE

For portrait photographers, wabi sabi has the potential to shape how we see, treat, and photograph our subjects. It raises questions like: Are we going to airbrush away the imperfections? Or are we going to embrace the flaws? Are we going to photograph only people with that perfect look who are deemed beautiful? Or can we learn from this great philosophy to find and value the imperfect beauty in us all?

Perhaps the reason you're reading this book is because the universe is asking you to adopt a new wabi sabi–like worldview. And maybe this new perspective will transform how you live. There is a shift beginning in our culture that is asking us to become more real. The word *authentic* is trending, and there's a reason for that; it comes from an ever-deepening need to be real.

In a world strained by social media, marketing, and hype, perfection is losing its appeal. In response, there's a collective awakening to the fact that being imperfect is okay. You don't have to have a certain kind of skin, body type, height, hair color, gender, or religious belief to be accepted and loved. More importantly, you don't have to pretend to be something you aren't.

This is a movement that we, as photographers, can contribute to in a meaningful way. As the image makers, we can help change the tide. And if there is any genre or type of photography that can help change how we act and how we view and value others, portraiture is it.

If we focus our energy, we can create a new body of portraiture work that reminds the world that while we are all different, we are also the same. We are all individuals with flaws who want to love and be loved. And maybe the universe is asking you to get involved. Maybe you're being asked to use your talent to help others live with more kindness and truth.

PART 03

MASTERING TECHNIQUE, GEAR, AND LIGHT

12

FINDING THE PERFECT PORTRAIT LENS

Carry less gear and capture more frames.

—Evan Chong

Without a lens, the camera is blind. But the lens gives the camera much more than clear sight. The lens is the one element of gear that most directly affects how our subject looks, and it shapes how we feel about a portrait.

ATTACH a telephoto lens and the zoomed-in view might draw your attention to someone's flaws. Try using a wide-angle lens on the same scene and suddenly your subject looks small. Of course, it's not just the lens but how we use it—a wide-angle lens from up close, far away, high, or low all give us a different look. The lenses we use and how we use them give us the means by which we express and capture different moods, feelings, and ideas.

Generalist photographers don't put much thought into what lens they use. They tend to use lenses that cover a wide range of subject matter. Wanting to photograph a bit of everything in every way possible, the generalist is content to use a 24–105mm or a 100–400mm lens. In contrast, portrait photographers prefer a specific lens for a particular look. Portrait photographers covet lenses that allow them to create a shallow depth of field. While these lenses create a unique look, they are expensive, heavy, and don't always focus well. But portrait photographers don't care. They prize their portrait lenses more than gold.

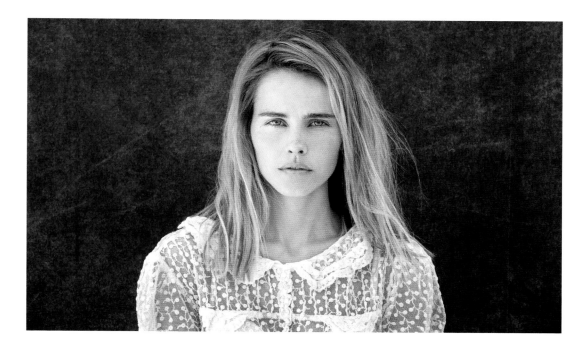

The various focal lengths also provide different looks. From a technical perspective, a big part of this look is created by the lens's intrinsic quality of compressing or distorting the scene. This is easiest to understand with wide-angle lenses. If we use a super wide-angle lens and move close to the subject, her face becomes warped and distorted in an unflattering way.

The images below show the difference between a 16mm (left) and 50mm (right) lens shot from the same exact spot. If we step back, the distortion becomes less noticeable, but can still negatively affect the look if the camera angle is too high or low. Be careful when you use lenses that are 35mm or wider if you don't want to have any distortion in the frame.

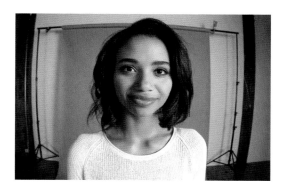

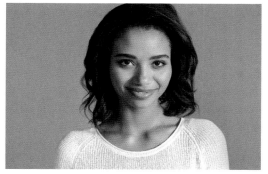

That said, some photographers bend the rules for effect. For example, if you get close (but not too close) with wide-angle lenses, you can create a sense of physical proximity, connection, and even drama in a portrait. One way to think about this is to step outside of portraiture for a moment and consider the ubiquitous GoPro and its super wide-angle lens. The wide angle of view creates a feeling of drama, as if you are right there as someone catches a wave, kayaks off a waterfall, or back-flips off a bridge. The lens creates a certain mood, which isn't good or bad. It just is.

While there are no hard and fast rules in portraiture, still there are some pitfalls that are best avoided when using wide-angle lenses. If you're going to use a wide-angle lens for a close-up portrait, make sure the subject is in the center of the frame, as there is less distortion there. The distortion increases the further away from the center of the lens you get. Or if you notice that the distortion is too strong, step back from the subject for a more desirable look.

Landscape photographers like wide-angle lenses because of how they create a sense of expansiveness, wonder, and awe. One of the ways they do this is by distorting our sense of perspective and scale. For example, these lenses can make trees seem taller and waves bigger than they actually are. They can also make other subjects seem unnaturally small, such as a person standing in a big wide-open scene. The point is that wide-angle lenses change our sense of proximity, size, and scale.

While wide-angle lenses distort the scene, longer focal length lenses flatten and compress it. And the longer the focal length, the stronger the effect. In other words, a 400mm lens compresses a scene more than a 100mm lens. So what exactly is compression, and why does it matter to portrait photographers?

Compression is the way a telephoto lens "flattens" the scene. First, it makes objects that are far away seem close, and second, it "compresses" the perceived space between the foreground and background, making it seem smaller than it really is. The first point is pretty easy to understand—when you look through a telephoto lens, far-away objects appear closer and bigger. Second, if you look at multiple objects stacked up in a scene, these objects seem much closer to each other than they really are. This gives you the ability to juxtapose elements in the foreground and background in exciting ways.

SOME PHOTOGRAPHERS BEND THE RULES FOR EFFECT.

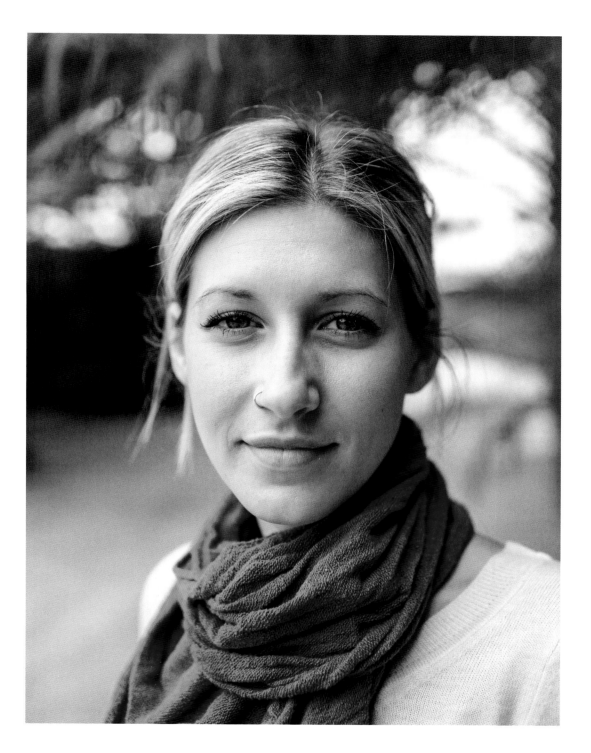

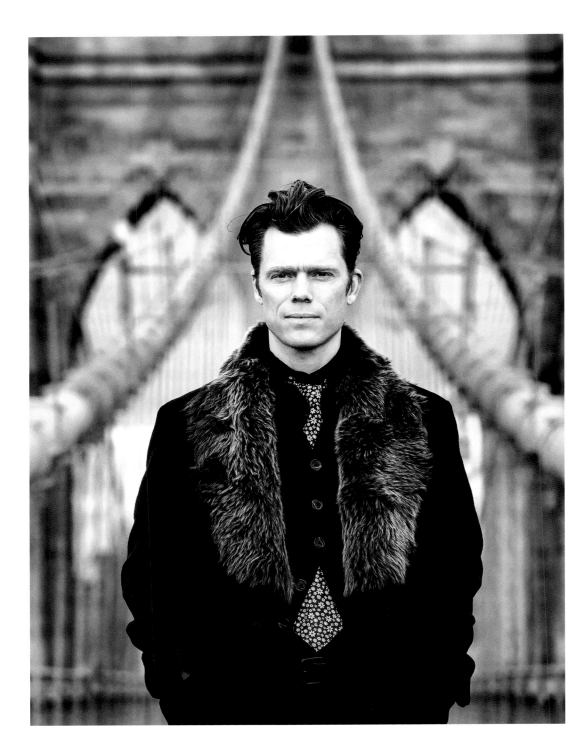

Not only does compression change the relationship between the subject and the background, it also compresses the features of your subject, which creates a more flattering look.

For this reason, it's generally recommended to use a focal length of 70mm or greater for a head-and-shoulders portrait. If you're going to include more of the body, like with a ¾-length or full-length portrait, a 50mm lens or wider is fine. These are only general rules of thumb, but they illustrate the point that the more the subject fills the frame, the longer the lens should be. The longer the lens is, the more compression and the more flattering the look.

When I first learned this "rule" I thought, "I can't wait to try capturing a portrait with a 300mm lens!" At the time I was teaching at a photo school and had easy access to a 300mm f/2.8. As I checked out the lens in its huge carrying case, I was struck with how heavy it was. No problem, I thought. Next, I recruited a friend to be the subject for a portrait shoot. When he was ready, I lifted up the lens—it was a beast, and quite difficult to hold. So I put it on a tripod and realized I had to move a long way back to get my subject in the frame. Once I was set, I practically had to yell to my subject if I wanted to be heard. Quickly, I realized that yelling feedback and posing suggestions wasn't going to work. Plus, my connection with the subject was lost because I had to stand so far away.

Since that experience I have come to learn that there are fashion and portrait photographers who use super long lenses like this. But this approach doesn't work for most, and it definitely doesn't work for me. For up-close portraits, I gravitate toward something like a 70–200mm or 85mm lens. For more environmental portraits, I like to use a 35mm, 50mm, or 24–70mm lens.

As a side note, the issue of weight isn't just something to consider if you want to use a 300mm lens. The weight of a lens is actually most closely linked to its quality and build. For portrait photographers, the best lenses are those that allow us to shoot with an extremely shallow depth of field. These lenses tend to have a better build quality and weigh more. Let's talk about weight in a moment. First let's focus on the more important topic of f/stop and depth of field.

DEPTH OF FIELD

A low aperture number like f/2.8 allows you to capture a shallow depth of field such that the subject's eyes are in focus and everything else is a blur. Used with intention, I find shallow depth of field to be a wonderful tool for creating a strong and soulful look. So, it's worth asking, "Why does f/1.4 or f/2.8 resonate with us in such a unique way?"

When a non-photographer looks at a portrait, they do not think about the f/stop or depth of field—the only thing that matters to them is how the portrait makes them feel. When it comes to depth of field, shallow equals profound. Because shallow replicates how the human heart sees. When you look at someone you love—your spouse on your wedding day, your daughter running into your arms, your best friend returning from overseas—you see him or her with an aperture setting of f/1.2. You focus on the eyes and the rest of the world becomes a blur. That's how affection works, and in real life, the narrower the area of focus, the more we care. See the images on the opposite page, which shows the subject standing in front of a dumpster to illustrate the point. The three photographs were captured with the same 85mm lens, but at apertures of f/10, f/2.8, and f/1.2 (from top to bottom).

When it comes to choosing a lens, I look for something that has the power to convey significance, soul, and depth. So I only purchase lenses that are f/2.8 or less—everything else seems, well, uninteresting and trite. Of course, this is my own biased view, but you already know that by now, as I'm the one writing this book. Your choices may be similar to mine, or they may be different, and that's okay. Most importantly, figure out what you like for yourself so that you can write your own rules and create photographs that resonate with you.

Why don't more people buy lenses that shoot at f/2.8 or less? These lenses cost more, weigh more, and are more difficult to use because capturing tack sharp images isn't easy when you're shooting at f/2.8 or less. And to that I say, "Exactly! That's exactly why I enjoy them so much." If it was easy, I think the photos might have less soul, feeling, or depth.

My landscape photography friends find my obsession with shallow depth of field ridiculous because it isn't relevant to them. They want a deep depth of field so that everything from the foreground to the background is tack sharp. This helps them capture a sense of scale, wonder, and awe.

But what works for a landscape doesn't for a portrait. And my goal is to create a soulful connection that feels real. I want to create portraits that draw the viewer into the frame in a very specific way. By using a shallow depth of field, the viewer searches the frame for the "area of focus" and ignores everything else.

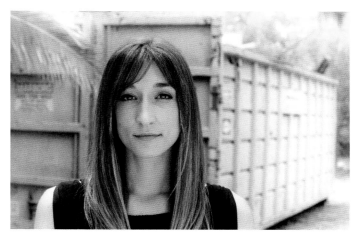

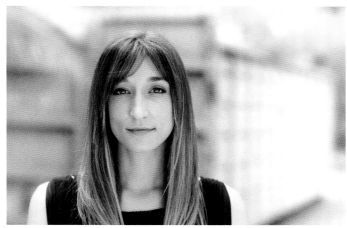

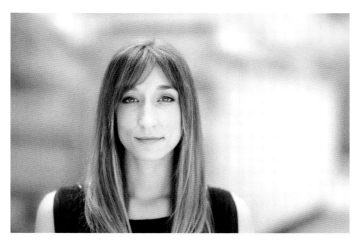

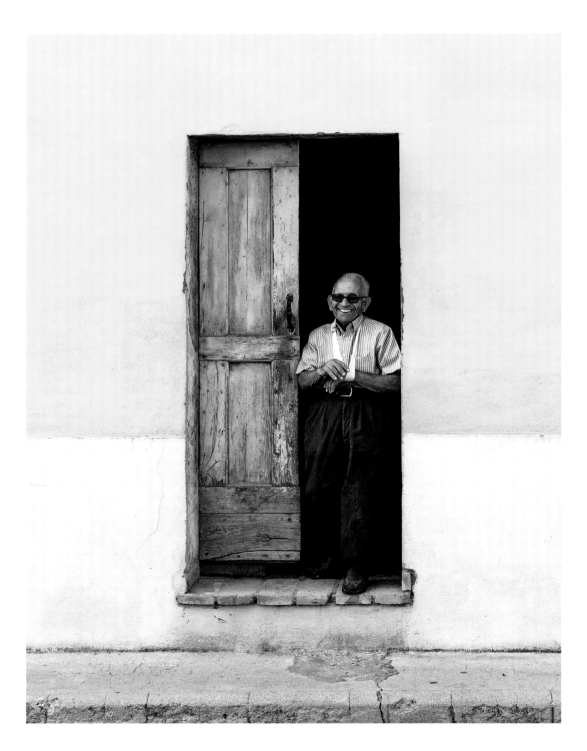

SIZE AND WEIGHT

All that said, whether you photograph landscapes or portraits, it's important to consider the practicality of the lens size and weight. For this reason, I own two versions of many of my favorite focal lengths. For example, I own two 85mm lenses (f/1.4 and f/1.8). The difference in size and weight is significant. The f/1.8 is much smaller and lighter, so I use that one when I'm traveling, like when I was in Italy and captured the image on the opposite page. I choose the f/1.4 when I can lug it around. I love that lens, so it's the one that goes with me most, but only when I'm up for dealing with the extra weight.

My point isn't to convince you to buy two 85mm lenses. I admit that is a bit excessive, but hey, it's kind of like the musician who buys two similar guitars; the subtle differences matter. My point is that you should consider size and weight when you buy a lens. Too often I have seen students buy the best gear (which always weighs the most) and then not end up using it because it's too big or it weighs too much. If a smaller and lighter lens will get you out shooting more often than a big heavy lens, choose small and light. The nimble photographer always captures more frames.

If you want to learn more about lenses, check out an online tutorial I've created called "Finding the Perfect Portrait Lens." In this course, I go over additional information and show examples with live shoots. If you'd like to view this course, as a reader of this book, you can get a discount code at chrisorwig.com/authenticportraits.

13

EXPOSURE SETTINGS

*The real voyage of discovery consists not in
seeking new landscapes, but in having new eyes.*

—Marcel Proust

The camera heightens our awareness of color, texture, details, and light, and it gives us the ability to notice what we might otherwise overlook. This is because the camera sees objectively, whereas the eye has trouble seeing in an unbiased way. Yet in spite of all the camera's objective and technological capability, it still sees the world in a slightly diminished way in comparison to the human eye. And it's not just that the camera sees a smaller angle of view or has a limited dynamic range when compared to the eye. It's that the camera isn't connected to anything but a small media card.

WITHOUT A HEART, mind, and soul, the camera's vision is limited. And, of course, without a camera operator who's interested and invested, the camera can't see anything at all. Until there's a connection between the photographer and the camera, the camera remains a machine waiting to be used.

Sometimes I like to think of the camera like a violin waiting to be played. And just as the violin has no voice on its own, neither does the violinist—both need each other in an inextricable way. That's why musicians become so attached to the instruments they play, and that's why we love our cameras so much.

In the next scenario (below), I was shooting into the sun, so I took an exposure reading, increased the Exposure Compensation setting, and the subject ended up nice and bright. Next, I wanted to see more of the background and create a silhouette, so I reduced the Exposure Compensation to create a darker image.

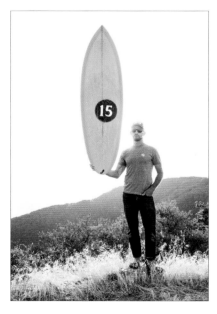 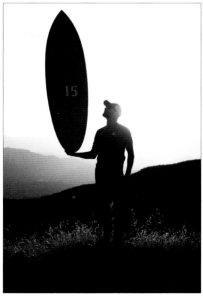

If you are looking for a simple and easy way to set your exposure, give Aperture Priority a try. As you work to capture the best exposure, remember that one exposure versus another isn't a black and white case of right versus wrong. Rather, determining the exposure is all about finding the right settings that help the camera see in a way that is aligned with your own vision and voice.

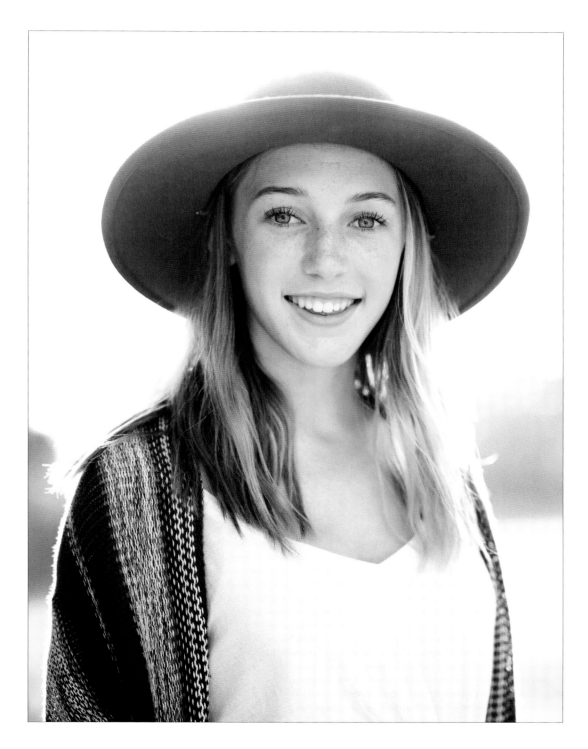

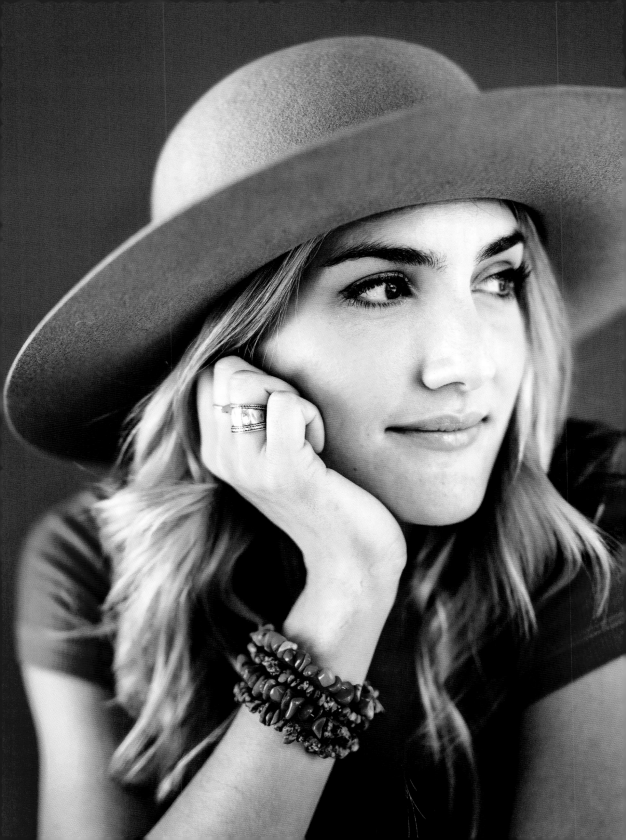

14

SEVEN PRINCIPLES OF NATURAL LIGHT

Out of clutter find simplicity.

—Albert Einstein

In order to make great photographs with natural light, we need to learn how to find and use that light in the most effective way. In a few moments, I'll share seven principles about natural light that can serve as a foundation for your ability to work with it.

That said, the best way to create a solid foundation is to first ignore what everyone else is doing and take some time for self-reflection so you can decide what type of approach you'd like to take. And rather than just thinking about photography, expand your reflection to include your approach to your other interests, passions, or hobbies.

FOR EXAMPLE, in my own hobbies and activities I like

to keep things simple. This is true whether I'm woodcarving, camping, surfing, biking, or capturing photographs. In almost everything I do, I like to keep things as simple as possible; I enjoy the creative challenge of working with limited gear. There is something about it that forces me to be creative and get on with the work. If I have too many lenses, too many tools, too many choices, my creative energy dissipates and drains. Knowing this about myself is important, because it means if I want to excel at something, I have to keep it simple.

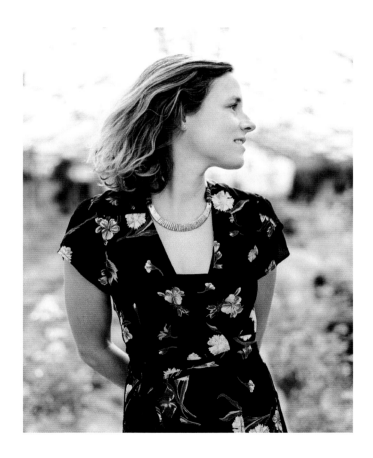

So when it comes to working with light, I choose natural and available light without modification or additional lights. (As a side note, I'm not against using studio lights; some of my favorite photographers work that way.) I tend to work without assistants and with gear that can fit into one small bag. Working this way is challenging, but I find the challenge revs up my creative energy in a unique way. I like working like this. I love how using natural light allows me to work in a nimble and flexible way and how I don't have to worry about cords, batteries, modifiers, sand bags, and stands. Plus, I enjoy being able to work anywhere rather than being confined to a specific studio space.

As I've come to learn all of this about myself, it has shaped both the way I approach light and the portraits I make.

But that's my story. What's yours? Maybe you prefer the quiet and comfort of working in front of a big window in an old barn. Or maybe you like the hustle and bustle of working out on the streets. Whatever it might be, take some time to clearly define your ideal work space, work habits, and workflow.

For me, figuring out this path hasn't been easy; it's taken years. It's one thing to like something, but it's another thing entirely to devote the time to learning how to excel. What I want for you is that you find and define what you love so you can work toward excelling at it. Too often photographers get good at something they don't like, which seems like a waste of energy, effort, and time. So begin by defining what you like. Next, figure out how to do that thing really well.

When it comes to figuring out what type of light and workflow you like, sometimes it's helpful to use a metaphor or analogy. For example, let's compare lighting to camping.

There are so many different ways to camp. The three most common are: backpacking, car camping, and using an RV. You might say working with natural light is like camping without a lot of gear. With natural light, all you need is what you carry on your back. Studio lighting is more like camping with an RV—you're outfitted with a generator power supply, comfortable chairs, and a kitchen sink.

Both forms of camping are valid and good, but with each you camp in different ways. So you need to figure out which type of camping you enjoy most. Camping isn't easy—it's a lot of work to buy the gear, pack it all up, and get where you want to go. If you are going to expend all that effort, do it for the type of camping you love. With photography, this is even more important because your affinity and passion for the light, location, and subject matter will come across in your frames.

As a side note, if you find yourself liking backpacking *and* RV camping (i.e. natural light and studio work), that's okay. The two approaches are not mutually exclusive. Maybe you want to shoot both in the studio and outdoors. That's great. But you still need to think of these activities as two separate things, and you will have to gain twice as many skills. As this book is mostly about natural light, let's continue to focus on that.

With that in mind, let's discuss seven foundational principles that serve as the bedrock of my approach to light.

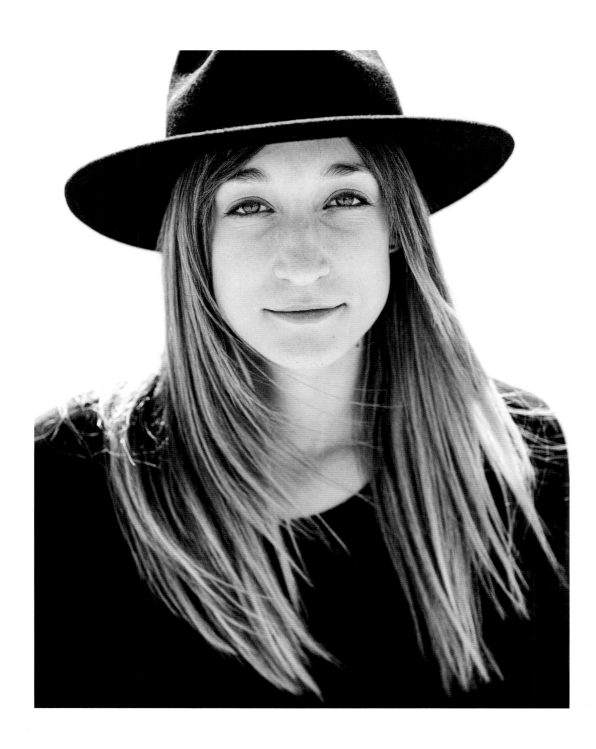

SEVEN PRINCIPLES OF NATURAL LIGHT

1. There is no such thing as bad light. Even though some light is golden and soft while other light is stark and harsh, it doesn't mean one type of light is intrinsically better or worse than another. If we start labeling light as good or bad, it quickly becomes a trap that limits what we create. This type of thinking can lead to becoming overly particular or snobbish about light, which can lead you to stop taking photographs, stop noticing, stop appreciating, and stop applying creative problem-solving with the light you do have.

This is exactly what happened to a young and talented photography student at the school where I used to teach. This young student won contests, impressed his teachers, and wowed his friends. His photographs were thoughtful, interesting, and deep. When he scheduled a trip home to South Africa, everyone was interested to see the photographs he would capture on his trip. Before leaving, he mentioned to a close friend, "More than anything, I can't wait to capture a meaningful photo of my Dad."

Upon returning, someone asked him, "Did you get a good portrait of your Dad?" He replied, "No, the light was never right. It was never quite good enough." Tragically, a few weeks later his father unexpectedly died. His son had missed the shot because he was too preoccupied with the light. Now, he invites anyone who has heard his story to pass it on with the hopes that no one else makes that same mistake.

Yes, the light is important. Yes, the light matters. Yes, certain light looks "better" or "worse." But don't let that limit the way you work. First, we all have to acknowledge that natural light will never be perfect because its quality, color, and brightness always change. That's why natural light photographers have to work quickly and learn to be adaptable. It's also why natural light photographers don't wait around but look for the light and then shoot no matter what. Don't get me wrong, I'm not saying they ignore or disregard the quality, color, intensity, look, or feel of the light. This isn't about being sloppy. Rather, it's about seizing the moment—problem-solving and appreciating the light for the way it appears.

Consider the harsh and high-contrast light we encounter around noon. Most photographers consider this kind of light useless and bad. But it isn't intrinsically bad; it's just not right for creating a colorful, soft, or flattering look. It might be the perfect light to create a high-contrast black and white image, such as the one on the opposite page.

2. Expensive lights or modifiers aren't essential. It's easy to fall into the trap that the more expensive the gear, the better the photographs will be. And studio lights are one of the most expensive things you can own. So it's helpful to remember that throughout the history of photography, many of the greatest portraits ever made were created with simple, minimal light. Just because some photographers create elaborate lighting setups, it doesn't mean that you need to do that, too. You can create powerful and timeless photographs without a lot of gear.

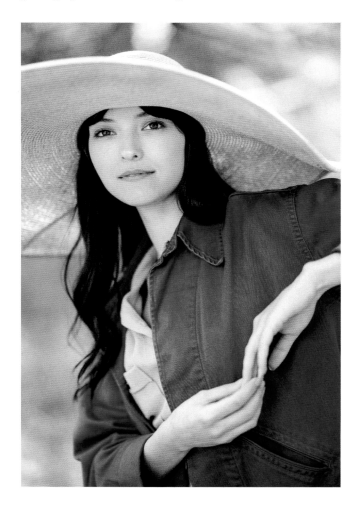

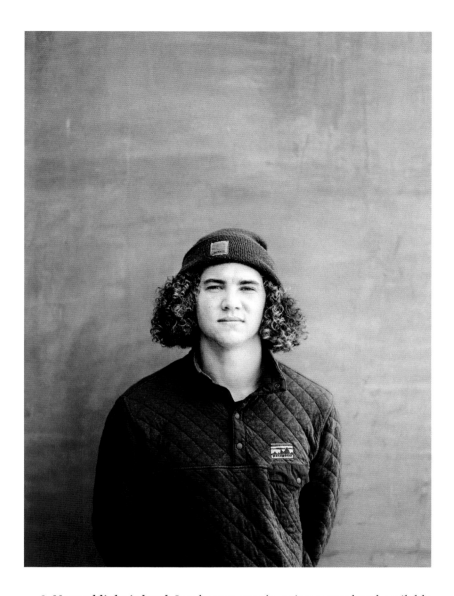

3. Natural light is hard. Just because you're using natural and available light doesn't mean that you don't have to work for your images. In some ways, you might even have to work harder, as you're working with something that is out of your control. It's kind of like the difference between sailing and driving a speedboat. The sailor can't change the wind, but she works hard to harness what's there.

4. It's the flaw that makes the frame. With studio lighting and portraiture, the goal is to create something that perfectly reveals. So it makes sense to retouch away every imperfection in both your subject and in the light. But with natural light portraiture, you have to keep it real, whether that's by retouching in a more subtle way or by simply letting the imperfections of the light shine through. These so-called "imperfections" are actually what make your photographs feel real. Resist the urge to use natural light in a way that looks overdone, or to over-retouch your images.

5. Capturing portraits with natural light is rewarding in a unique way. For me, it feels kind of like making something with your own two hands. It is very gratifying to create a meaningful photograph with nothing more than a camera and lens. Plus, it's enjoyable to be able to walk around and move freely. It allows you to photograph anywhere and at any time. You just have to learn how to see, feel, and work with the light you have.

6. Natural light portraiture requires a touch of Zen. In the West we tend to emphasize rational and logical thought. In contrast, a more Eastern approach emphasizes intuition, mindfulness, and openness. One definition of Zen that I find helpful: "Zen is a state of calm attentiveness in which one's actions are guided by intuition rather than by conscious effort." Or think about when people use the word Zen as a kind of slang, like when they say, "Going to the spa was so Zen"; they're essentially saying that the experience was peaceful and relaxing.

Getting good at natural light portraiture requires a more intuitive, relaxed, and peaceful approach. Rather than controlling or shaping the light, you remain open and mindful in your work to make the most with the light you have.

7. Natural light can be used to create professional results. You don't have to use studio lights to create professional work. Just look at the work of Kat Irlin, Steve McCurry, Irving Penn, Richard Avedon, Rodney Smith, Anton Corbijn, Jose Villa, Peter Lindbergh, and Elizabeth Messina, and you'll see what I mean. Many photographers, myself included, have built a career using natural light.

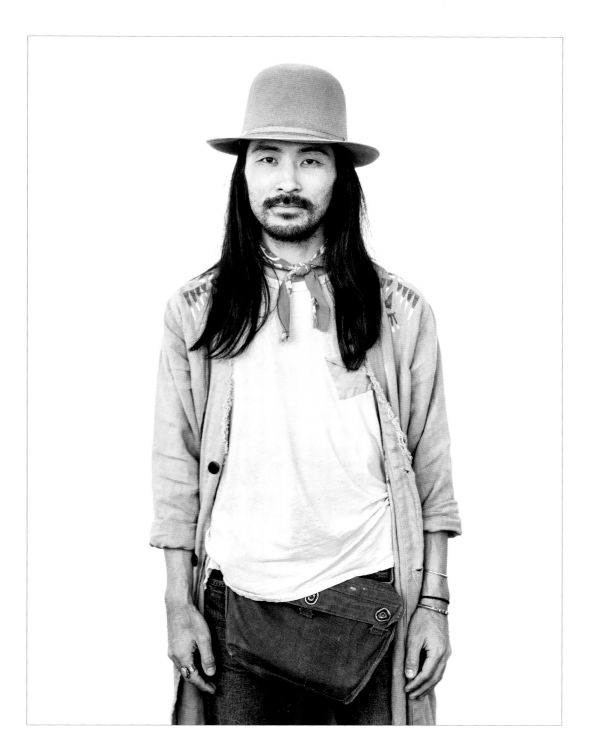

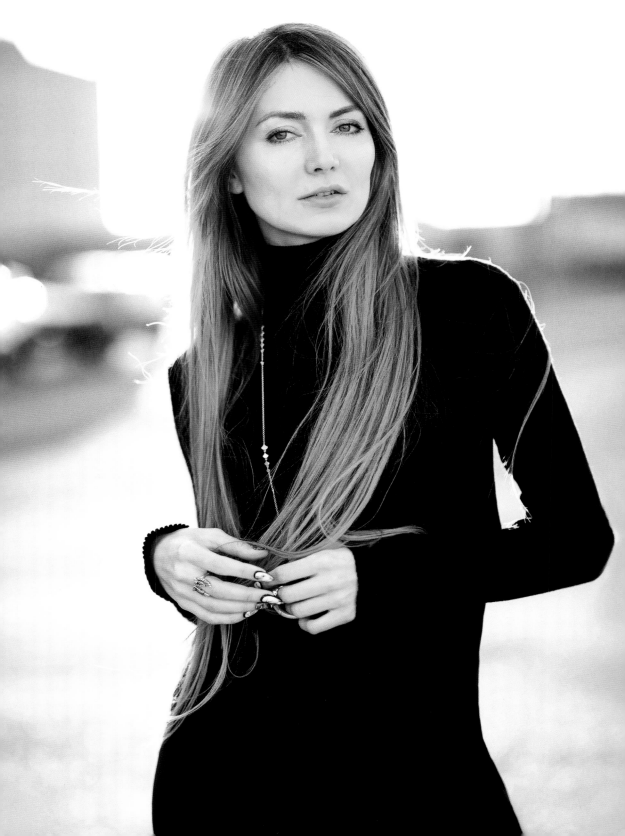

15
WORKING WITH NATURAL LIGHT

Beauty is not in the face; beauty is a light in the heart.

—KAHLIL GIBRAN

What I search for in a portrait isn't a look; it's light.

Take a moment to pause and look at the light surrounding you. How many different colors, qualities, and intensities of light do you see? How far does the light travel from that nearby lamp? Where do the shadows start and stop? How many reflections can you see? How does the light reveal or conceal the shape of the objects around you? Set down this book, close your eyes for a few seconds, and then open them wide. Take it all in for a minute or two as you observe light in its many forms.

Did you see anything new? Did you notice an increased sensitivity to the subtlety and character of light?

USUALLY when we pause to notice, it stirs and heightens the senses in a new way. That's one reason why photography is perhaps the world's most popular and practiced pastime—it changes how we see and experience the world.

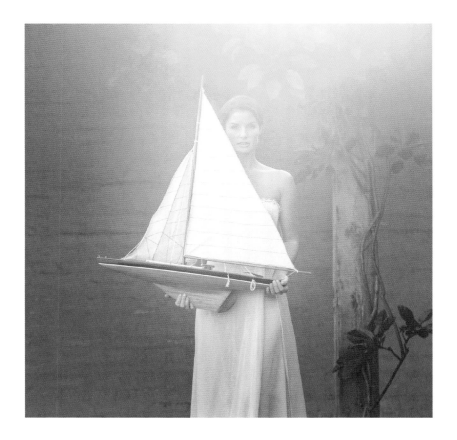

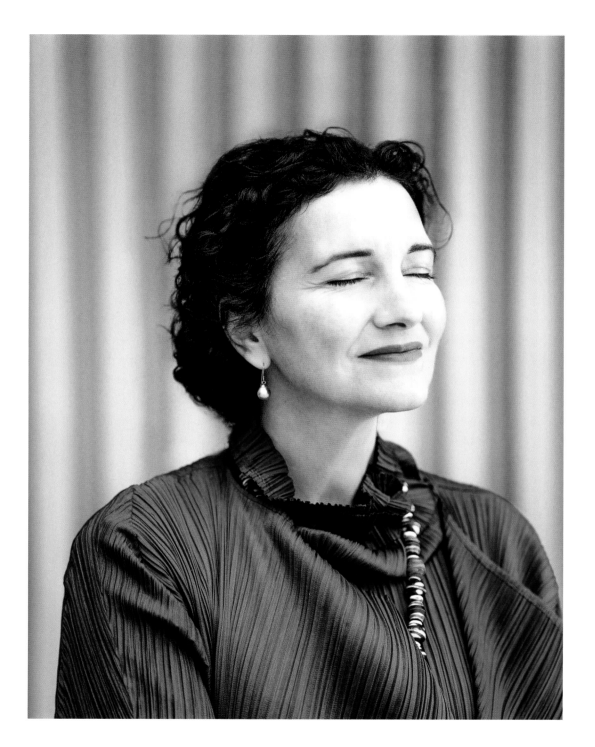

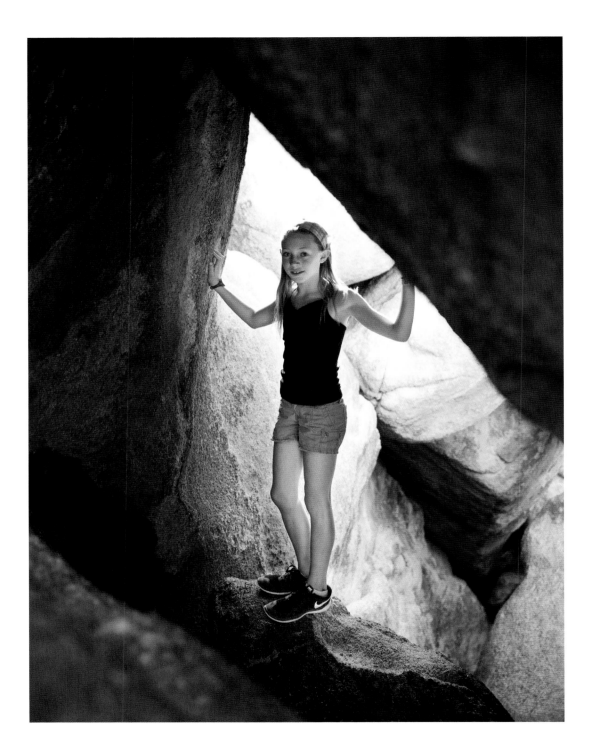

PHOTOGRAPHY AND LIFE

Those who intentionally practice the craft of natural light photography receive an unexpected gift—a heightened awareness and appreciation of light. The more you look, the more you see, and the more you see, the more you feel, know, and understand. Searching for and noticing light is something that not only expands your vision, it also affects how you think and what you feel. Like other sensory experiences (taste, touch, hearing), the external experience affects us in an internal way.

Unfortunately, modernity has desensitized us to how we experience life. All the oversaturated colors, dizzying lights, amplified sounds, and flavorful foods have dulled our senses. But when we leave the distractions of the city and head out to the simplicity of the wilderness, it gives our senses a chance to resuscitate, recalibrate, and come alive.

Every year, my daughters and I join a group of friends for a father/kid camping trip in the deserts of Joshua Tree National Park. I find the simplicity of the desert more refreshing each year. Maybe that's because the more complicated life becomes, the more I need the simplicity that can only be found in a place with nothing but sand, cactus, and giant rocks. Being out in the desert scrubs my soul clean. The result is a clarified vision of how I see the world and the people I love. It helps me notice and appreciate qualities, characteristics, and other things I had completely overlooked.

But the reality is that we can't always leave "real life" and go to the desert to be restored.

We need to find a way to feel and experience life in the midst of all the hustle and bustle. I think this is why the current trend of mindfulness is so widespread. It's a restorative movement that seeks to counteract the feeling of being overwhelmed. Mindfulness and meditation have gone mainstream—not because mindfulness and meditation are new, but because we desperately need what they provide. In my own life, I find meditation to be a wonderful gift that restores my sanity and declutters my internal life.

Meditation is the practice of cleaning out the clutter, and it does this through purposeful sensory deprivation. Meditation provides its practitioners an opportunity to stop thinking, stop worrying, stop listening, stop looking, and stop tasting, and to simply be quiet wherever they are. This practice gives us the ability to re-enter the busyness of life without letting the noise take over and direct our every move. Meditation reduces stress and raises mindful awareness, which allows us to respond rather than react.

When it comes to creating better natural light portraits, this is exactly what we need. We need to learn to look at the world in an uncluttered way. Rather than falling prey to the distractions from all the visual noise, we have to develop a mindful sensitivity to the subtlety of light and how it affects what we see and feel. One way to do this is to develop a working vocabulary for talking about light. Because the language we learn might help us cultivate a more mindful approach.

TALKING ABOUT LIGHT

One way to talk about light is to think about different light characteristics: intensity, direction, quality, color, feeling, mood, direct, indirect. Another way is to focus on light scenarios that work for portraiture: backlight, side light, dappled light, window light, doorway light, and shade. Let's begin with the qualities and characteristics of light.

At the simplest level, we can think about light as being direct or indirect. Direct light is hard, harsh, and complex, as it renders strong contrast between highlight and shadow. Think of direct light as the sun shining directly and intensely on your subject without anything blocking or diminishing its power. This works well when you want that high-contrast or edgy kind of look.

Indirect light is the opposite. This is light that is blocked or filtered by tree branches, a building, or the earth's atmosphere at sunrise or sunset. Indirect light is most commonly used in portraiture because it is simple, soft, flattering, and subtle. One way to deepen our understanding of the difference between direct and indirect light is to examine a particular lighting scenario. Let's take window light, for example.

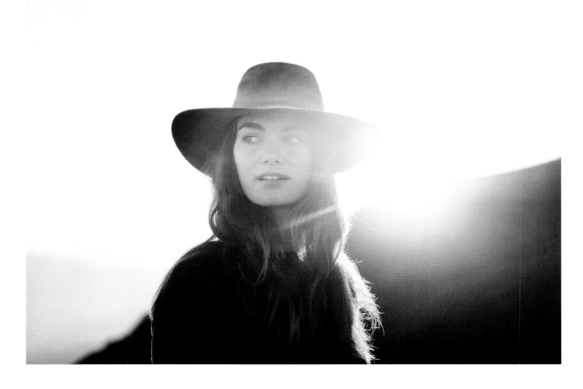

For centuries, artists have used window light as a source of inspiration and illumination for their craft. For portraitists in the northern hemisphere, the most highly coveted light is from a window that faces north so that the light never directly (or harshly) enters the window but comes in with a soft and beautiful touch.

In contrast, a southern-facing window is open to direct sunshine and will experience direct light raking in at different angles throughout the day. Place a subject in front of a big south-facing window and you'll see bright harsh light mixed with angular and strong shadows that fall on the subject. This isn't necessarily bad, but it is complex; creating a good portrait with light like this can be really challenging. Harsh direct light is unforgiving in how it deals with wrinkles, blemishes, and flaws, so you have to work hard to find the best posing, position, camera angle, and exposure. Plus, you have to consider how the light is affecting your subject—sitting in or looking toward direct light can be hot, difficult, and tiring.

In comparison, working with a north-facing window is relatively easy. With a big north-facing window, the light is smooth, soft, subtle, and kind. Ask a subject to sit in front of a north-facing window and she'll instantly be at ease as she stares out the window with a fond and pensive look. With north-facing light, you can work more slowly to find just the right position, posture, and proximity to the window because the light is so subtle and soft. The main consideration for window light portraiture is how close or far away you place the subject from the window. Position the subject close to the window, and you get a softer look. If you move the subject back or to the side of the window, the light will fall off to create deeper shadows and more contrast.

Considering this comparison between direct and indirect window light, it becomes clear that in order to notice and work with different types of light, it's helpful to think about light in non-technical or non-photographic terms. Yes, we need to understand what window light is, but we also need to consider how the light feels—whether that's harsh and edgy like direct window light, or thoughtful and kind like indirect window light. We need to resist the urge to call light "good" or "bad." It depends on the type of portrait we want to make.

As you no doubt know by now, I prefer working with soft and indirect light versus harsh and high-contrast light. That said, I admire how some photographers use direct light to cut to the chase and create raw and strong photographs—like the photo on the cover of the album *The Legend of Johnny Cash*, which I am listening to right now. Someday I hope to create a strong photograph like that.

The messages I keep repeating to myself are, "Don't get so enamored of one type of light that you ignore the rest. And just because some light is difficult to work with doesn't mean it isn't any good. It's less about the light and more about me. Stop blaming the quality of light for your missed frames, and start making the most with whatever light you have."

With that in mind, let's take a closer look at the main light scenarios that tend to work well for portraiture: backlight, side light, dappled light, window light, doorway light, and open/covered shade.

BACKLIGHT

Backlight is created by shooting directly into the light source. This often means having the subject place his or her back to the sun while you point your camera directly toward the subject and the light. This is difficult to do when the sun is high in the sky, so most backlit photos are captured at sunrise or sunset. That said, occasionally I'll find a scenario where a wall or object reflects light and can be used to backlight as well.

Shooting backlit photographs is amazing, but it's potentially harmful for your eyes. Never look through your camera when it's pointed directly at the sun. Instead, protect your eyes and look at the LCD screen, or use the electronic viewfinder (EVF) if you have one. All of the Sony cameras I use have an EVF; it's one of my favorite features and one of the many reasons I switched to shooting with a mirrorless system. With an EVF, you are always looking at a digitally created version of the scene rather than the scene itself. This is a godsend for photographers who like to create backlit photographs.

Next, choose an exposure setting so that you have enough detail on the subject without completely overexposing the background. For me, this typically means I tend to slightly underexpose backlit photos, then in Lightroom I boost the exposure and shadows, add contrast, recover the highlights as needed, and fine-tune the color. As a side note, when working on backlit photographs, keep in mind that you can take more liberty when it comes to creating vibrant yet still believable colors—the viewer tends to expect a more saturated and interesting color palette with images captured this way.

I enjoy shooting backlit photographs because of the way it allows me to create images with such a range of expression. With slight changes to camera position and subject, you can create looks that are atmospheric, dream-like, flattering, nostalgic, beautiful, warm, and soft. How you position the subject and your camera allows you to "turn up or turn down" the desired look. For example, with the image on page 152, the amount of lens flare creates a dream-like moment, whereas the photo on the opposite page uses backlight to create a more subtle mood.

Keep in mind that with a backlit photo, the sun and the resulting lens flare don't necessarily need to be visible in the frame. There are so many different ways to create backlit photographs that it's one of my all-time favorite types of light. It's never the same twice, and it's an option I look for whenever I can.

And even though I love backlight, I've learned that I need to be careful with how it's used. It creates such a strong look, and sometimes that look goes against the type of portrait I need to make, or worse, sometimes backlight just doesn't look good on certain subjects. Like if I'm trying to photograph someone who is strong and tough, backlight can be too soft and ethereal. Just because backlight is beautiful light doesn't mean it's always the right choice.

SIDE LIGHT

While backlight tends to be limited to working at the beginning or end of the day, side light is more available throughout the day. What is side light? Put simply, side light comes in at an angle and creates a look whereby the subject is brighter on one side of their face and body, and darker on the other.

Sometimes the effect of side light is subtle (opposite page), and other times more dramatic (page 156). Side light can be found outdoors, indoors, with window light, or in open shade. Take a look at the pair of images on page 157 (top) to see the difference between side and back light. Both photos were captured at the same time of day but used the light differently. The same is true with the photo on page 157 (bottom), which was shot at the same time as the backlit image on page 153. Comparing those images can help you see how the same light can be used in different ways.

Side light works by adding shape, texture, and dimension to your portrait subjects. Unlike backlight, side light doesn't draw attention to itself. It provides the potential for mood, depth, dimension, character, beauty, and more. Perhaps most importantly, side light carries with it a sense of narrative or story.

For example, in cinematic lighting you will often see a type of side light called "split lighting," where one side of the face is lit and the other side is very dark. This is used to convey the idea of, say, a split personality for a character—both light and dark, good and bad. This type of light creates empathy and identification for the viewer because, truth be told, we are all a mix of darkness and light.

My favorite window light picture to date is a portrait of my mom (opposite page). My mom is one of my greatest inspirations. Not only has she fought off breast cancer, skin cancer, and colon cancer, she has done it all with a sense of humor and strong faith, and without letting any of it prevent her from living in a vibrant way. I made this portrait at a time when my mom was undergoing treatment for colon cancer. The image was captured during the filming of an online course with CreativeLive called "Capturing Authentic Portraits of Family and Kids." I wanted to make the course personal, so I invited my mom to come to the San Francisco studio.

My mom sat on a stool in front of a black piece of foam core as a large bank of windows illuminated the scene. The lighting could not have been simpler, but it was all that was needed to capture a significant and important portrait. That's really what window light provides us—the ability to unobtrusively capture profound and wonderful portraits. Too often these days we get tricked into thinking we need expensive gear, but using window light is the best way to dispel that myth.

If you don't have beautiful window light in your own home, you can almost always find it somewhere nearby. I've never lived in a home or had a studio with beautiful window light. Someday I hope to, but until then I make do by searching for great window light everywhere I go.

DOORWAY/GARAGE LIGHT

Doorways big and small create some of the best natural light available. If I could only choose one light scenario as my favorite, this would be it. There is something about how it illuminates the subject and lights up their eyes. The catchlights (the reflections in the eyes) always look amazing. And standing or sitting in an enclosed area and looking out a door has a psychological and subconscious effect. I'm not sure exactly what it is, but I embrace the mystery and magic that happen when we stand near the threshold and look out at the world.

This type of light is similar to window light but it's often bigger, more dramatic, and more straight-on. By comparison, window light typically lights the subject from the side because the photographer doesn't want to stand in front of the window and block the light. With doorway light, you can step in front of the opening and ask the subject to look out.

And you can position your subject in multiple ways for different looks. They can be at the foot of the door for an even and bright look (opposite page), where the catchlights are huge and the light is even. Or you can ask them to step back from the opening for a more dramatic look (below), where the light gains more contrast and the background appears dark.

When setting up a shot with doorway or garage light, keep in mind that your eye and your camera will see the scene differently. The eye will see the subject and everything else behind the subject; the eye can see a huge range of tones. The camera, on the other hand, can't match the eye's ability to see both light and dark. The camera will be able to see the subject, while everything behind the subject will go dark or completely black. Knowing this is a helpful insight because it means you can create a dark or evenly toned background really easily without having to set anything up (opposite page).

Of course, if you don't want a completely dark background, you can always put something (a different backdrop, for example) behind the subject. For example, you could place a piece of white foam core behind the subject, which would act to bounce and wrap light around him (see page 347).

The main thing to keep in mind with door and garage light is to first have the subject face the light, and then experiment—moving a few feet or just a slight turn can make all the difference.

If you want this type of light but don't have a garage or doorway with the right kind of light, you can always create this look yourself. I had to do this during one of my recent workshops. I asked a few students to hold fabric and black foam core behind and on the sides of the subject. Then I made sure he was facing the light and began to shoot (see pages 338 and 339 in Chapter 27). This approach also works outdoors—though it becomes a little less like doorway light and more like open shade. Let's talk about that next.

OPEN AND COVERED SHADE

Before I knew anything about portraiture, a friend advised me to make portraits in the shade because direct sun was too harsh and it made people squint. That simple bit of advice still rings true. Shade is one of the most forgiving and wonderful places to captures portraits. But working in shade is more complex than simply asking your subject to stand in the shadows. To create great portraits in shade, you need to have a keen awareness of light, where to stand, and where to have the subject look. Before we get into that, let's discuss two different types of shade—open and covered.

Open shade is shade that is created by an object—whether that's a building, wall, truck, etc.—where there is also no horizontal structure above the shade; the space above is open with no "ceiling." In contrast, covered shade is shade created by a building where there is also, say, an overhanging ledge above.

As I mentioned in the previous section, if you can't find shade, you can always create it. For this shoot of the actress Isabel Lucas (opposite page), we were working around the middle of the day. The light was harsh and the location was less than ideal. So I used tape and a piece of indigo fabric to create a background, created a stool with a stack of buckets, and the subject's friend held a piece of foam core overhead in order to create shade. The setup was so rigged that I took a behind-the-scenes shot, and I'm glad I did. It serves as a reminder that you can create great light wherever you are.

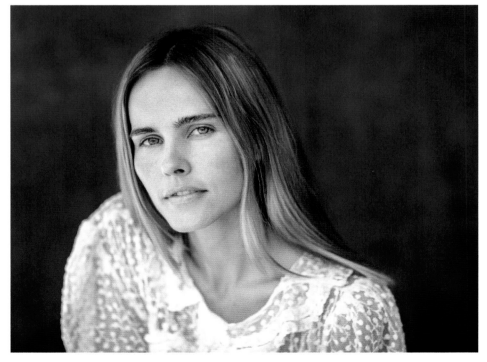

Open shade and covered shade aren't only good for actresses. Shade can be good for anyone, whether it's a chef (below), graffiti artist (opposite page), or CEO (page 172). The best thing about learning how to use shade is that it allows you to work at any time during the day. Rather than being limited by "good" light, you simply need to find a small shadow and have your subject turn toward the light; that light will not only illuminate your subject but can give them great catchlights, too.

The catchlight is a bright, shiny spot in the eye that can make the eyes look alive. To make sure you get a catchlight, have the subject stand in the shade and look toward the light. If you're having a tough time seeing the catchlights, have the subject wear a pair of reflective sunglasses and study the reflections that you see. The catchlight will mimic those reflections but in a more subtle way.

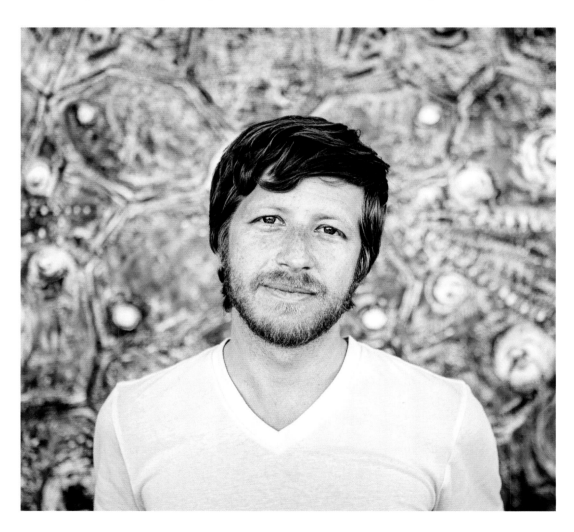

PART 04

THE SITTER
AND THE SUBJECT

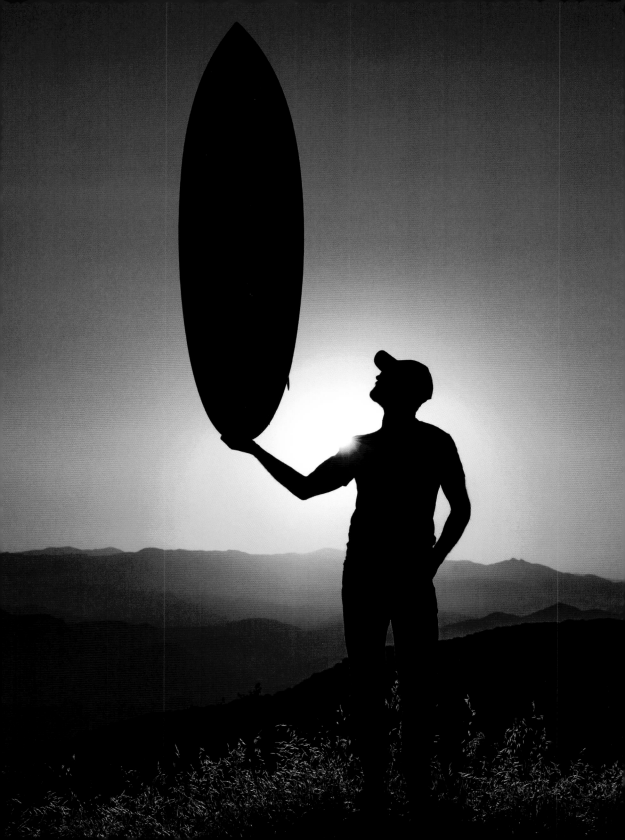

16
FINDING SUBJECTS

All journeys have secret destinations
of which the traveler is unaware.

—Martin Buber

One of the aims of authentic portraiture is to find and photograph subjects that are real—real people with aspirations, flaws, dreams, busy schedules, and emotions that fluctuate every day. Authentic portraiture isn't the domain of the ideal. And it isn't something that requires an excessive amount of time. A significant portrait can be made in a moment on a street corner. Mihaela Noroc's work is a great example of this. Mi is a photographer who travels the globe. Her book, *The Atlas of Beauty*, stands as a great testament that exquisite and profound portraiture can take place anywhere in the world, whether on the street, in a shop, or any other location.

THE BEST PORTRAIT

photographers don't obsess over makeup, clothes, or the perfect light. Like my friend Mark Seliger, one of the greatest portrait photographers of all time. The last time I was in his New York studio, he was showing me a lighting setup he created using lights from a hardware store that cost ten dollars. He was using them to create a high-contrast look. And right next to that was an elaborate set with top-of-the-line Profoto lights in a dizzying configuration. Mark is someone who isn't bound by the rules, and he doesn't obsess or worry about making mistakes. Instead, he takes risks that have led him to create some of the most iconic images of our time.

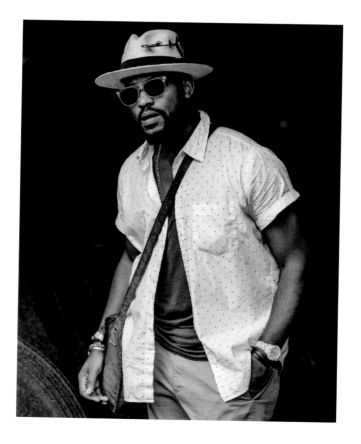

CATCHING THE WAVE

I live in the coastal town of Santa Barbara and surf whenever I can. Being around this kind of surf and beach culture has made me realize that most surfers don't obsess over how they look. Rather, they take a casual approach to life. But when it comes to catching waves, they work hard because there is nothing in the world like riding a wave—the feeling is divine. But if you can't catch the wave, you won't be able to ride at all. When learning how to surf, catching the wave is the most critical first step. It requires an understanding of what you can and can't see—the breaking waves and the rocks, reefs, and ocean floor. These latter factors affect how the water moves and help you understand where a wave breaks and why. A surfer's strong understanding of the ocean makes all the difference between catching waves or sitting there and watching other people have all the fun.

When there's a good swell at my favorite surf break, there are often a few hundred other surfers trying to catch the same wave. As you can imagine, this makes it incredibly difficult and competitive to catch a wave. The best surfers are the ones who know where to be, when to paddle, and which waves to catch. It isn't enough to be able to catch a wave; you have to know *which* waves are setting up to provide the best ride. Great surfers are always the best at catching waves. And, of course, the more waves you catch, the better you become; and the better you become, the more wave-hungry you get.

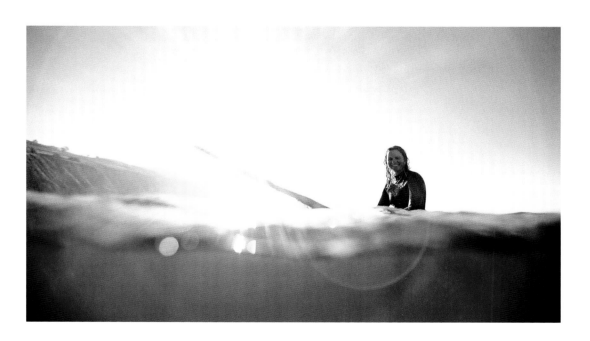

But the art of catching waves is almost always overlooked—no one films or photographs it, and it's difficult to teach. It is a skill you have to learn on your own, and therefore it holds back a lot of people, especially when the waves are big.

I mention all of this because there is a parallel between catching a wave in surfing and finding subjects to photograph in portraiture. It is our essential first step and there's an art to it, but that art often goes overlooked, especially in the photo education world. Most instruction assumes that you can find or hire subjects, sitters, or models, and quickly moves on to focus on teaching what to do next. Yet for me, finding subjects was (and still is) the biggest hurdle to improving my craft. Early on, finding subjects felt like I was fighting an invisible riptide or an onslaught of crashing waves.

Eventually I learned a few techniques that really helped. In this section, I want to save you from the unnecessary struggle I went through and share what I've learned so that you can learn to find, catch, and connect with the right kind of subjects for the images you want to make.

SITTERS, SUBJECTS, AND MODELS

Before we dive into the process of finding subjects to photograph, let's pause to define a few terms related to how portraits are made. The person with the camera is obviously the photographer, but what do we call the person being photographed? The model? The subject? The sitter?

Really any of these terms will work, but each has a different connotation. The term "sitter" has been inherited from traditional painting. Because painting a portrait took so long, the sitter would wait patiently while the painter did her work. While this term is still used in photography, it tends to suggest a person sitting at rest in a studio, and it implies a sense of presence and a hint of gravitas. The term "subject" can carry with it the idea of hierarchy (think about "the king and his subjects") or it can be a more neutral term. I like to think of it as a term that clarifies the main focus of the shoot. Finally, a "model" is typically someone who poses for an artist, and the term carries a hint of idealism. Usually models have a specific look.

But I like to photograph everyone, regardless of how long they are willing to sit or how beautiful they are. So I use the term subject, not because it's the best term, but because it covers a broad range. For example, if I'm photographing an architect, I might say, "John the architect was the subject for my shoot today," but I probably wouldn't say, "John the architect was the model for my shoot."

More than anything, I want you to know that when I use the term subject I use it in a positive and respectful way, as I always see subjects as people with souls, stories, passions, and fears. So the question remains: How do we find better subjects to photograph so that we capture more meaningful frames?

FINDING SUBJECTS WAS (AND STILL IS) THE BIGGEST HURDLE TO IMPROVING MY CRAFT.

BEGIN WHERE YOU ARE

Finding subjects begins with your mindset. Just like catching a wave, you have to believe it can be done. You also need to abandon "if-only" thinking. If-only photographers say things like, "If only I had a studio... If only I had a better camera... If only I lived in New York... If only I was friends with a model..." If-only thinking can be helpful when it motivates you to set goals and work hard, but more often than not it simply becomes an excuse.

To find subjects and create great portraits, you have to take advantage of where you live. This is how most great portrait photographers start. They make the most with what they have, wherever they find themselves.

Before I was an established photographer, I was a web designer and was once invited to speak at a design conference in the beautiful seaside town of Brighton, UK. I brought a camera along, and after my presentation, I hit the streets to capture some frames. After photographing some buildings, I decided to try to create a set of photographs of strangers in front of some beautiful and colorful beach huts.

The lessons I learned from this experience have become invaluable to me. And although I was photographing strangers on this day, I apply these lessons learned to almost every portrait photo shoot I'm on, whether it's a commission, corporate job, or personal project.

At the time I didn't have any experience photographing strangers, but I wanted to give it a try. It was a sunny day, and I waited for people to walk by. With every stranger I met, I explained myself (more on how to do this later) and asked, "Can I capture your portrait?" Most said no, which wasn't a surprise. But the first lesson I learned came from those who most frequently said "Yes"— it wasn't who I had guessed it would be. I already knew that not everyone wants to have their portrait made, but I was surprised that the most photogenic, beautiful, handsome, and striking subjects almost always said no, while the least photogenic usually said something like, "Sure, why not?"

Before this experience, I assumed that the most beautiful and "put together" people would be the ones most likely to say yes. But I discovered that we all have some degree of shyness, insecurity, or disinterest—even if we look amazing. Since this experience, I've talked with models and actors who have confirmed this impression.

The first lesson is simply this: Just because someone is attractive or has a "look" doesn't mean they want their image made.

ABANDON "IF-ONLY" THINKING.

ROAD MAP

If the first step in capturing good portraits is to define what you like and to learn how to notice those opportunities in the real world, then the second step is to work on your approach— and this is true whether you're photographing someone you just met or someone for a commissioned job.

It's one thing to notice someone beautiful, stunning, or strong; it's another thing to muster up the courage to approach that person and ask if you can make their portrait. One of the ways you can gain courage is to tune in with the thoughts that might be holding you back.

When I see someone I'd like to photograph, an inner dialogue begins between my "inner artist" and my more rational side. It goes something like this: "Hey Chris, you should capture a portrait of that person!" says the inner artist. Instantly, the rational part of me argues back, "No. Not right now. Maybe later." The inner artist responds, "Come on. Risk is the substance accomplishments are made of." The rational side of my brain responds, "Sure, but what if they say no?"

I imagine the script in your own head may vary from mine, but we all have internal debates like this, right? Approaching someone and asking for permission to create a portrait is hard; it requires risk. And it's a risk that doesn't come naturally to many. But if we want to capture better portraits, it's a risk we have to take. So what's the best way to proceed?

Here are a few general concepts that I follow:

BE EMPATHETIC. Think about the situation from their perspective.

BE YOURSELF. Nobody likes a fake, and everybody can tell when you're trying to be someone you're not.

BE CASUAL. Don't overdo the pitch.

BE CLEAR. Explain who you are, what type of work you create, and what type of portrait you would like to make.

BE THOUGHTFUL. Honor and respect the person's response.

BE BOLD. Take a deep breath and take the risk. Great portraits won't happen any other way.

Before you approach someone, it's helpful to put yourself in the potential subject's shoes and realize that they have no idea what's going on in your head. The last thing they are thinking is, "Wouldn't it be nice if that person walked up to me and asked if she could capture my portrait?"

Next, get your own thoughts in order. This begins with an awareness of what is racing through your mind. When I see someone I'd like to photograph, it's exciting, but this excitement can easily muddle my thoughts. So when I see someone who would make an amazing portrait subject (my father walking through a creek, a yoga instructor practicing on the beach, a famous artist at my local coffee shop), the first thing I do is take a breath and slow down. The trick is to approach people in a calm and mindful way—just like you might approach an injured horse that is tangled up in a piece of rope. As horse trainers will tell you, if you're anxious and on edge, it will only go from bad to worse.

Then I play out the conversation that is bouncing around in my head. Mostly I try to make sense of the competing messages I hear between my inner artist and my more rational self. For example, I might hear, "Wait, Chris. Don't do this. This is crazy. Who are you to capture their portrait? There's no way this person would agree to having a portrait made. They will think you're a weirdo. Maybe you are a weirdo? Don't do this." But then I listen for the photographer-artist voice, which gently encourages me to take the risk. With a kind tone, this voice provides a nudge: "Hey, why not? You might capture something wonderful. And art requires risk, doesn't it? All the photographs, at least the good ones, required a risk. And this is a risk you should be willing to take. Go for it."

At this point, I take another breath and feel the courage fill up my lungs. Then I start to imagine or previsualize the interaction going in a positive way. I also put myself back into their shoes and remember that they, too, have a lot of thoughts spinning in their head. Maybe they're in a hurry, maybe they're stressed, or maybe they're just enjoying a moment alone. It is impossible to know what they're thinking, but just like me, they are involved in some kind of thought process.

With all this in mind, here's a road map I use.

STEP 1: Take a breath and calm down.

STEP 2: Have your camera out of its bag and hang it on your shoulder. Its visibility will help you break the ice, and people are more open to talking to a stranger who has a camera hanging off his shoulder.

STEP 3: Think about what you're going to say and rehearse your lines.

STEP 4: Start with something that shows a touch of empathy like, "I'm sorry to bother you..." or "This is completely out of the blue...."

STEP 5: Explain who you are and ask for help. "Frame and blame."

18
PRE-SHOOT PREP

When opportunity comes, it's too late to prepare.

—John Wooden

When it's a setup portrait shoot—whether for assignment or a personal project—you will have more lead time to think about your approach. With more time, you have the options to either do research, previsualize, and plan the shoot, or do nothing so that you can approach the shoot in a fresh, spontaneous, and uncluttered way. There are merits to each option. For me, I always like to do a little bit of work ahead of time, especially because I tend to find my best ideas when it's quiet and I'm alone.

CREATING CHARACTER MAPS

Before a shoot, I do a bit of research and think about the subject so that I can make the most of our time when we meet. One way that I use the research is to create a visual map with a journal.

This was the case when I photographed my friend Drew (below), who was a host for CreativeLive, an online education site. I was scheduled to photograph him for a course I was teaching, and the shoot was going to be filmed and broadcast live. (As a side note, if you're interested, you can view that course, "Capturing Authentic Photographs," on creativelive.com.)

Needless to say, I was nervous. I don't like being filmed while I work because it makes everything feel fake. Usually, when I photograph someone it's just the subject and me. Working one on one is a much easier and more natural way for me to operate and thrive. But for the sake of the course and for the students watching it, the shoot needed to be filmed. With that in mind, I knew that it would be essential to pull out my journal and begin to sketch out a few ideas ahead of time. If you have a shoot that you're nervous about, researching your subject and creating a visual character map can be a big help.

When it comes to creating visual character maps, keep it simple. I begin by putting the subject's name in the center of the page. Next, I write down what comes to mind, based on what I know of the subject through both research and the time I may have already spent with them. You can see the visual map for Drew at right.

These maps have nothing to do with composition, gear, or light. The goal of the visual map is simply to get in touch with who this person is and how I think about them. It's easy to get caught up in the moment and forget the deeper side of who someone is. This exercise helps me see the person with more dimension and depth. After I create the visual map, I spend time crafting the vision for the shoot.

CRAFTING YOUR VISION

As I've said from the get-go, photography is arguably one of the easiest art forms to practice, yet it's one of the most difficult when it comes to developing your own vision, voice, and style. Taking a picture is easy, but making a good portrait is hard. And strangely, it's as much of a challenge for me now as it was when I started out—as I evolve as a photographer, my standards and goals grow right along with me. So regardless of your skill level, I've found it immensely helpful to craft a vision, strategy, and plan.

Think of your vision as the end goal and ideal for the shoot. What is the photograph you would love to make? To craft your vision, ask questions such as:

- What does the portrait look like?
- How does the portrait feel?
- Is the mood somber, strong, bright, happy, clear, crisp, or complex?
- How much space does the subject take up in the frame?
- Is it a close-up or more of an environmental portrait?
- Is the composition empty and open, or classic and full?

After brainstorming a few ideas, write out a concise vision for the shoot.

Here's how I do this. For every shoot, my ultimate vision is to connect with the subject in a meaningful way. For me, the connection is more important than the photograph itself. For many of my photography students, this priority is hard to digest. They ask, "Isn't the whole point the photograph? Isn't that your job?" For me, the whole point isn't the photograph. With everyone I photograph, my hope is to create a positive bond. And this goal isn't just limited to portraiture; my aim in life is to connect with those I meet and uplift others in any way that I can. So as a photographer, I'm willing to sacrifice the frame for the sake of the subject. To put it simply: people first, photographs second. That principle guides the vision that I shape next.

For example, before photographing Jeff for a sunglasses company, I started with a visual map. Next, I reminded myself that the portrait wasn't the end goal; making a solid connection with Jeff was the true end goal. Then, I crafted a vision with a few simple words: *Sunrise. Top of the mountains. Hats. Sunglasses. Surfboard. Portraits. Environmental portraits. Bouldering. Wardrobe: jeans and simple shirts. Classic. Cool. Badass yet approachable. California vibe.* After articulating the vision, I shared a pared-down version with Jeff to make sure he was on board.

With the vision clarified, it was time to think about what gear would best allow me to actualize that vision. The gear to consider for this shoot included: cameras, lenses, backdrops, and location necessities. I wanted to keep it simple, so I brought one camera and two lenses—35mm and 50mm. Jeff is a minimalist in all that he does. It seemed appropriate to keep things simple on my end as well. Looking back at the images now, I wish I had brought a longer lens, such as an 85mm, so the close-up shots had less distortion. But hey, we all live and learn, and that's what makes photography so much fun.

Speaking of mistakes, there are two others I'd like to share from this shoot. First, I had Jeff stand still too much. When I reflect on the shoot, I think I approached it too much like a portrait photographer and not enough like a lifestyle photographer. To create authentic lifestyle photographs, you need to get your subjects to move. The more movement, the better—it makes it seem like something is really happening in the scene. Second, this was my first time shooting for a sunglasses company. As a result, during the shoot I was thinking too much about the product (sunglasses) and not enough about the overall feeling and vibe.

All in all, the photographs turned out fine, but after every shoot it's worthwhile to ask yourself what went well and what you could have done better. Then write down what you've learned so you can create a catalog of wisdom that you've gained.

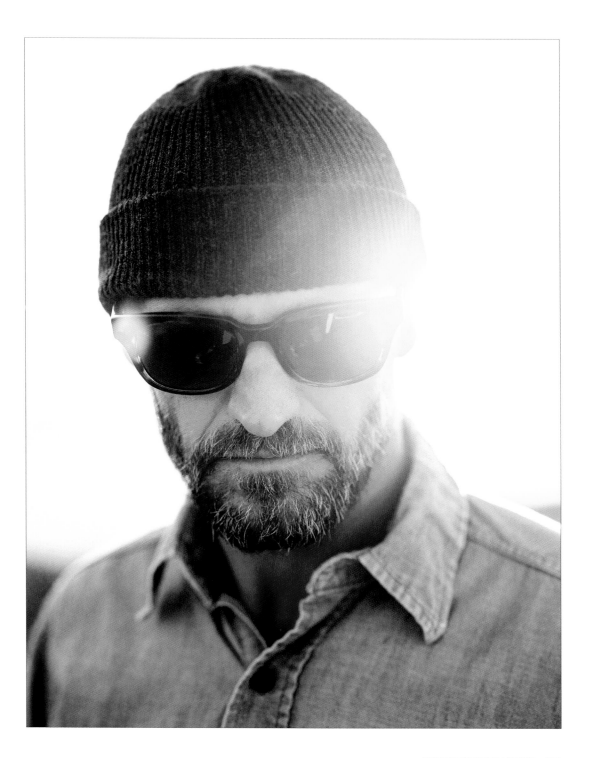

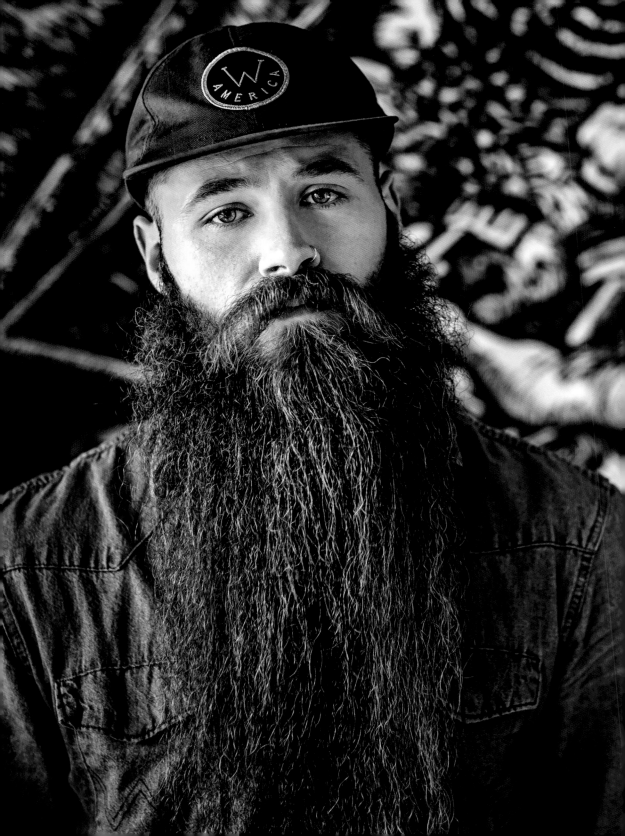

19
PREPARING YOURSELF

All things are ready, if our mind be so.
—William Shakespeare

Unlike other types of photography, portraiture is a two-way street. It requires equal amounts of honesty, vulnerability, and skill from both parties—the subject and the photographer. Because a good portrait is the result of the chemistry, collaboration, and connection between those two souls.

But sometimes we're impatient, and if there isn't a spark of inspiration we choose the easier and less interesting path of asking our subjects to pose. We ask the subject to tilt her head, position her arms, and perhaps smile. These "impatient portraits" can be beautiful, but they're rarely profound.

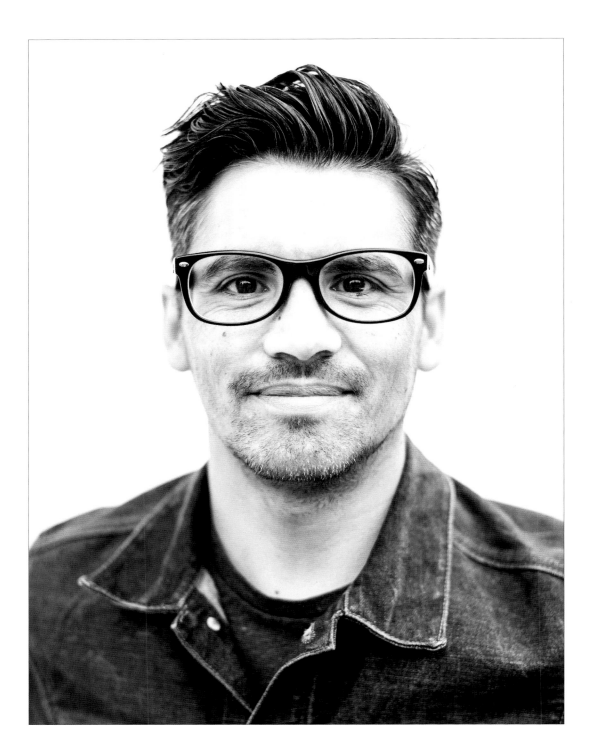

PROFUNDITY is a sacred space established without the use of words. It's like a soul-to-soul agreement between two people willing to be vulnerable and real. In portrait sessions, I've watched this space materialize in unexpected ways, and then vaporize as quickly as it came. You must take advantage of it right away because you can never tell how long it will last. One time it quickly appears and then instantly fades like the passing of sunlight through clouds. Another time, it lingers like a winter calm.

However long it lasts, it is always, ultimately, temporary. And in a flash, what felt like a meaningful moment is gone. But if a portrait was made, that moment lives on.

As photographers, we can't create these opportunities alone, but we can take steps to prepare ourselves for them. It begins with a desire to present our best self. The subject in front of our lens has sharp eyes and looks to us for guidance. Even if we don't say anything, the subject picks up on every cue. I think this happens because, when someone is in front of a camera, an amplified sensory experience begins. It's also during these moments that the subject's self-talk begins. Combine the two—self-talk and amplified senses—and you've got a powerful force that can have a huge impact on the shoot.

REFLECTING BACK

Depending on the current state of mind, the subject's self-talk might include innocuous questions like, "How's my hair look?" or "Does this jacket look cool?" But it may also include more difficult thoughts, such as, "I look horrible. My nose is big. Why am I doing this?! Ugh!" Stranded and stuck in front of the camera, the subject needs help—even the most confident and secure person can use some support. But it's difficult to give that support if our own self-talk isn't positive.

If you're harboring negative thoughts, emotions, or vibes, it casts a shadow on your subject and on the shoot. The deeper the negativity—resentment, regret, anger, or disappointment—the darker and colder the shadow becomes. No matter how much you smile or try to hide that negativity, the subject knows; being in front of the camera heightens their sensitivity to emotions of any kind.

When most subjects first have a camera pointed their way, they get a gut feeling of insecurity. Being photographed is a vulnerable experience. Many subjects (myself included) need some kind of feedback; it's like looking in a mirror to double-check how they appear. But without any reflective surface nearby, the subject looks to the photographer with questioning eyes, asking, "Do I look okay?" or "How should I stand?" Some subjects feel embarrassed to ask these questions, so they say nothing at all. But they look to you. If the subject sees a frustrated photographer, she assumes it's her fault. If she sees a stressed and distracted photographer, she wonders if he really cares. If she sees a happy photographer, she assumes she looks good.

As the portrait photographer, *you* are the mirror. And the subject picks up and reflects back what *you* give them.

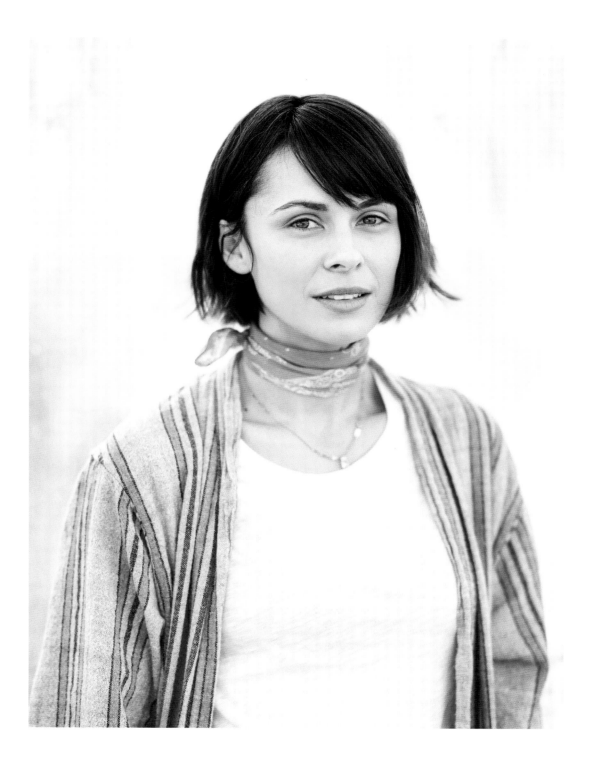

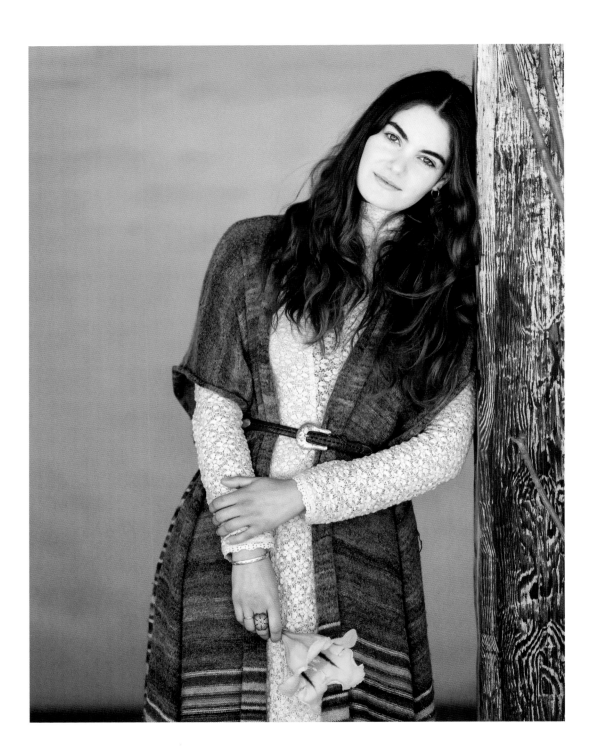

PRE-SHOOT RITUALS

If we agree that the portrait photographer acts like a mirror for the subject, before the shoot your first step is to wipe that reflective piece of glass clean. This needs to happen first so that later we can use that mirror to direct and pose as we'll talk about in Chapters 22 and 23. You have to first cleanse yourself of any negativity, then replace that with kind thoughts and good vibes. Roald Dahl put it this way: "A person who has good thoughts cannot ever be ugly. You can have a wonky nose and a crooked mouth and a double chin and stick-out teeth, but if you have good thoughts it will shine out of your face like sunbeams and you will always look lovely." And that shining disposition will put your subjects at ease and draw out their light. In return, their light will shine back and draw out your best self in a reciprocal way.

So what do you do when you're not feeling bright and happy? What if you're stressed and exhausted? The best thing to do is accept the situation and maintain awareness of it, rather than getting more frustrated and mad— more negative energy only makes it worse. Next, ask yourself, "What would help clear away the clutter, dirt, and grime?" Sometimes the answer is as simple as taking a deep breath. Other times it's helpful to take a few minutes to express gratitude for whatever you can. Most importantly, don't be fake or untrue to yourself. Become aware of the inner landscape of your life, but do so in a real and authentic way.

Another helpful strategy is to develop a pre-shoot ritual. For example, before I go out and make photos, I always remove the depleted batteries and replace them with ones that are fully charged. This has saved me more than once. You can do the same with your inner life. Try stretching, going for a quiet walk, closing your eyes and breathing, or practicing a brief mindfulness meditation to recharge the batteries of your soul and allow you to become fully present for the shoot.

Science is now proving what we have long known intuitively—meditation offers countless benefits. Numerous studies have proven that it reduces stress, increases attention to detail, strengthens our ability to relate to others, improves self-confidence, boosts creativity, improves concentration, strengthens relationships, deepens one's presence, and increases happiness. There are many resources out there, but if you haven't ever tried meditation, I have something that might help.

I recorded an audio meditation for portrait photographers called "Mindful Portraiture." You can find it on my site (chrisorwig.com/mindful) and listen or download the guided meditation. It's designed to recenter you in preparation for a portrait shoot. When I listen to it, it helps me get in the zone. It's kind of like a quick cleanse for the soul, allowing you to feel fresh before a portrait shoot.

The aim of any pre-shoot ritual is to start fresh so that the shoot goes smoothly—regardless of whether it's a high-energy production or one that's more poetic and Zen. When you take the time to prepare yourself, it leads to better results. Try it for yourself and you'll see what I mean.

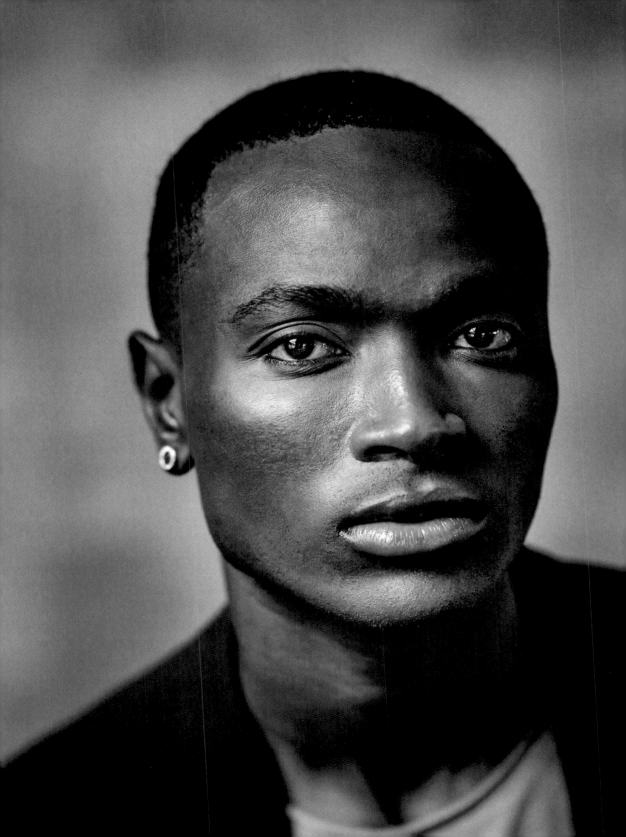

20

PHOTOGRAPH PEOPLE, NOT LABELS

Once you label me, you negate me.

—Søren Kierkegaard

As we've discussed throughout this book, a common pitfall in portraiture is to confuse how someone looks with who someone is. While looks and identity are related, they are not the same thing. So let's look at how we can put this philosophy into practice as we capture portraits. It all starts with how we think, so let's begin there.

The core of this book is the idea that portraiture is not about photographing a "label"—a model, musician, athlete, artist, surfer, or CEO. It's about photographing complex humans with their own fears, interests, experiences, dreams, and souls.

THE ONLY way to make portraits that go past the surface is to think past the surface ourselves.

So begin by thinking about the people you connect with most—your friends, family, classmates, and colleagues. What is it about them that is unique? I bet it's not what's on the surface, but something deeper and more profound.

These deep and meaningful connections are always based on something other than labels, looks, talent, or skill. Most likely, these connections are fostered by a seeing and knowing that goes past the surface of things. My best and closest friends don't care (or even really know) what I do for my job, and they don't care how I look, how fast I can run, or how well I can surf. But they do care deeply about who I am, about my dreams, hopes, challenges, failures, and fears. These friends know and accept me for who I am, not what I do. This is true for significant relationships of any kind, including those related to work.

When I first started to work with Lynda Weinman (founder of the education website lynda.com; see page 172 in Chapter 15), she saw past my inexperience and instead saw skills inside me that I didn't know were there. She took a risk on a young and inexperienced teacher and believed I would excel when she hired me to author a course. She saw past my insecurities and lack of formal skills. She saw well beyond my surface, and I am grateful she looked inside me and saw more. People who do this are the kind of people I want to be around, and in their actions I see the kind of person I want to become.

Apply this same logic and this same kind of seeing to your portraiture, and it will change the end result. When we see deeply and find the hidden light within, it sparks interest and forges a strong bond; the resulting photographs aren't created by the camera, lens, or light, but by the connection between two hearts, minds, and souls.

That's why I define my job as a portrait photographer as someone who is called to identify and capture the strength, beauty, light, and wonder that's within the subject. It is my job to find their inner essence, draw it out, and capture it in a single frame. This task is important to me in a crucial, elemental way, because finding someone's inner essence isn't just related to portraiture for me; it's related to how I interact with people on a day-to-day basis.

Coming up with your own job definition will clarify your approach. Take a few minutes to write yours out.

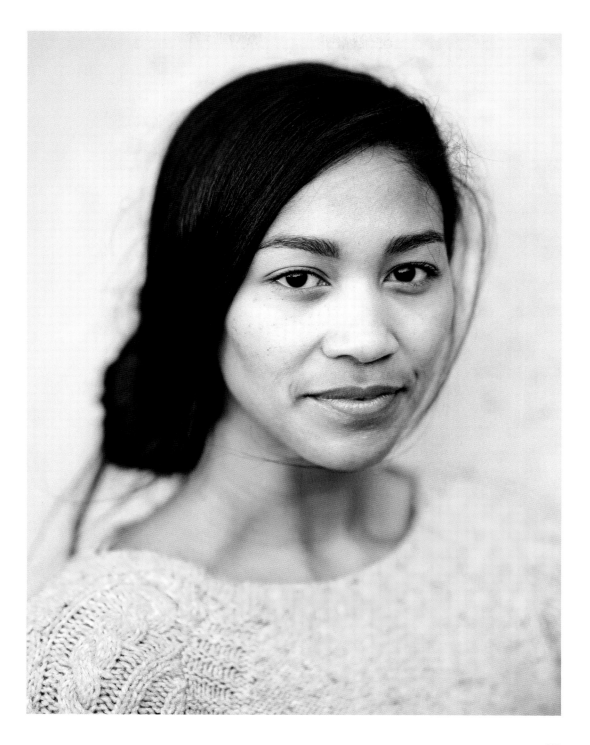

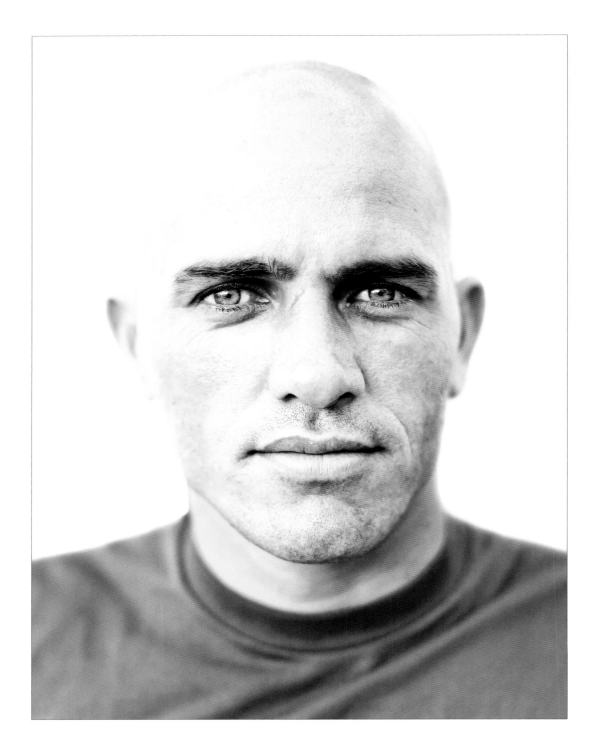

PHOTOGRAPH PEOPLE, NOT LABELS

THE STRUGGLE

Armed with a solid self-understanding and self-proclaimed job description, it's typically easy to photograph your friends and to look past the label and achieve a portrait that matches your own vision and voice. Yet, this becomes difficult when we start photographing people who are different from us. Whether that difference is age, gender, or celebrity doesn't really matter. What matters is the degree of difference or "otherness" we feel.

THE CHALLENGE WE FACE IS TO FIND THE HUMANITY WITHIN.

When I was set to photograph the eleven-time world champion surfer Kelly Slater (opposite page), I was well aware of the differences between he and I. But I knew that if I focused on those differences, I wouldn't be able to create a portrait that was very good. The same was true when I photographed the other subjects shown in this chapter. In all of these situations, I was photographing people who were different based on their age, fame, or ethnicity. So rather than looking at the obvious differences, the challenge we face is to find the humanity within. One of the ways we do that is to see past the surface.

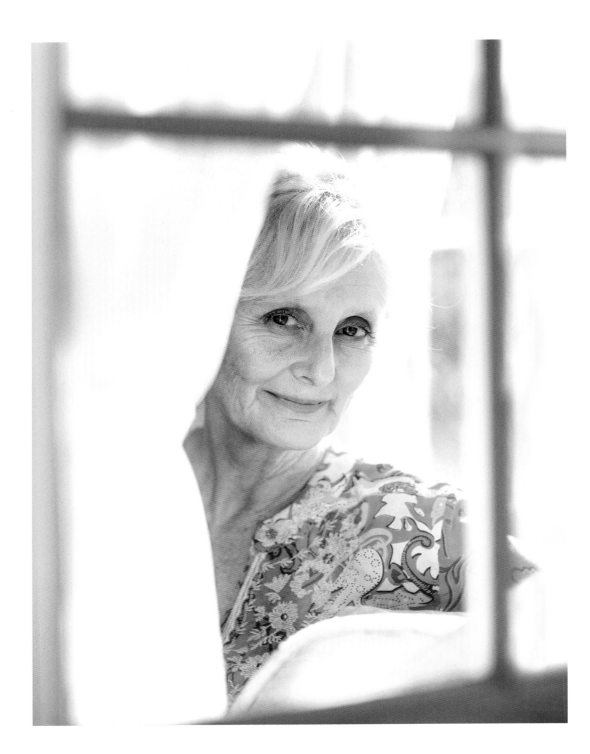

ENCOURAGE AND BUILD UP

The first step is to recognize the subject's inner essence, and the second step is to draw it out. We'll talk more about how to do this in the next few chapters. For now, one of the best ways to do this is to follow the words of the ancient Greek text, "Therefore encourage one another and build each other up." When it comes to drawing out the inner essence and giving feedback to your subject, I think that about sums it up. To "encourage and build up" is what we do when we smile, express kindness, and care for others in a practical way. That encouragement spreads and creates an open and caring atmosphere that makes it possible for the soul to come into view.

For example, with the images mentioned earlier, let me explain my approach. When photographing Kelly Slater I didn't talk about his accomplishments or treat him special in any way. Most celebrities prefer that you treat them like everyone else and sometimes that is the greatest act of kindness and encouragement you can provide—that is, to treat them like a real human with needs, wants, and dreams. By doing so, I think we can see a bit of his soul drift into view.

Another example of this is with the photograph that opens this chapter. The subject was a complete stranger, but I could tell he had a deep soul. So I approached him and asked if I could take his portrait. He agreed and we began to chat. It was quickly evident that he was a thoughtful and strong person. After sharing a few words, I asked him to look toward the camera and I captured a few frames.

When I met Rick Smolan (opposite page), I was excited to talk with him about photography. We have a couple of common friends and talked about that and about all the photography books he's produced (he is a former *Time*, *Life*, and *National Geographic* photographer). I mentioned how much I enjoyed his work and his approach. As I was taking his portrait, I said, "You have one of the best mustaches of any photographer I know." It was a simple comment that made him smile and helped me create a more meaningful frame.

When it comes to directing subjects, my approach is mostly about simply noticing and being kind, which is why I shy away from the idea of the photographer as someone who authoritatively "tells the subject what to do." Rather, I see my portrait sessions as a chance to get to know someone, to be kind, to care, and to shine a light on what's inside. This approach gives the tone of my shoots a less formal and more conversational feeling, and it helps me create portraits that are decidedly less posed but aim to feel more sincere. This doesn't work all the time, but that's my goal.

For the most part, I focus on making the connection (more on this later), though I also use other techniques: posing, movement, mirroring, breath, and eye contact. But if I work too hard on getting the perfect pose, my subjects sometimes end up looking more like cardboard cutouts of themselves rather than the real thing. So, as needed, I let go of creating the perfect pose in favor of creating something that feels genuine and real.

Still, posing is immensely important, so in the next few chapters let's talk about how to do both—how to pose and how to direct and connect in some practical ways.

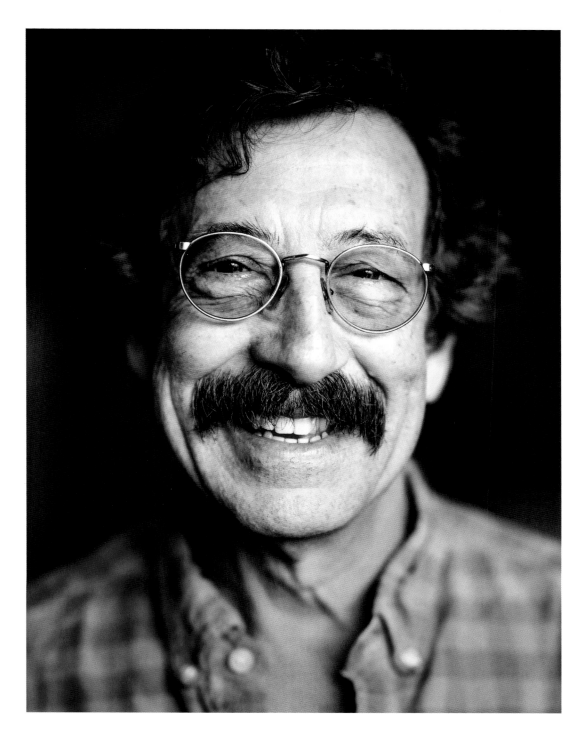

PART 05

POSING, DIRECTING, AND CONNECTING

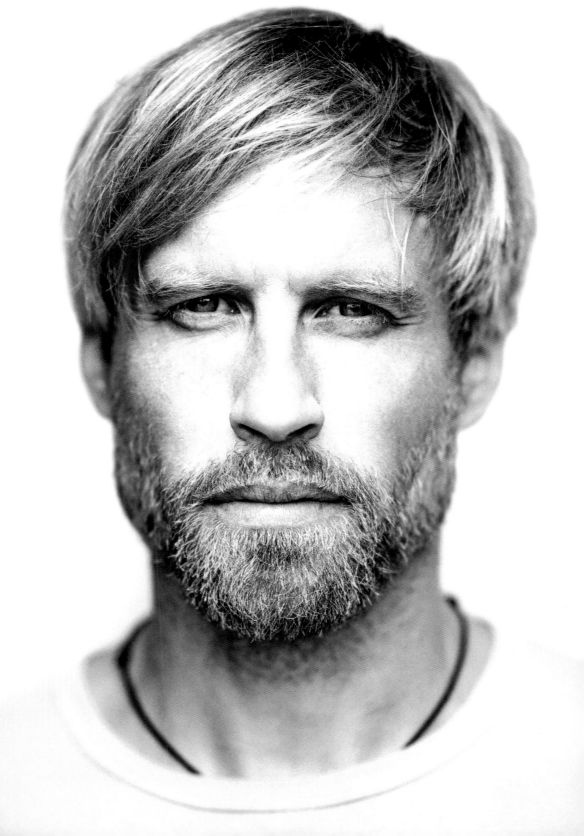

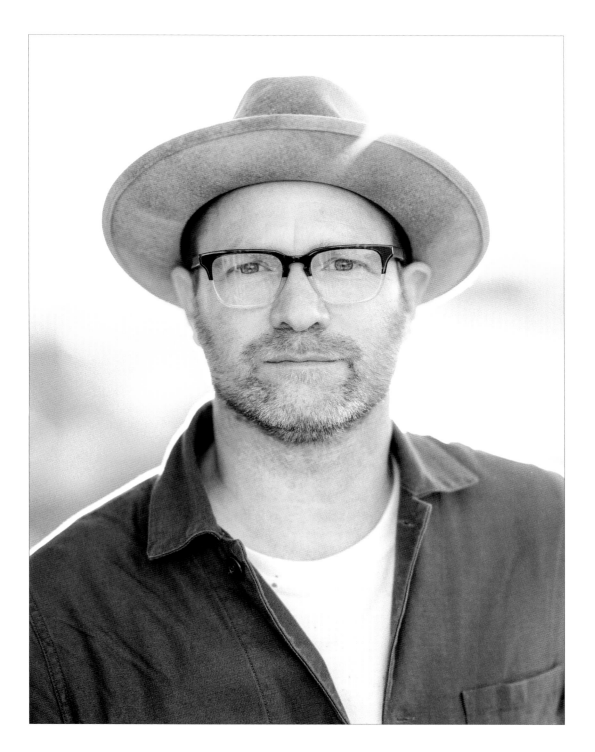

JOURNALIST: There are times when I appreciate the journalistic approach, like when I notice a natural and honest reaction across the room, but mostly I find it too "hands off." Journalism is too objective for me. I like to subjectively influence the photographs I create. I like to get in and work close, rather than capture from a distance. And I really like to share ideas, collaborate, and connect with the subject. So I only use this approach on occasion. And when I do, rarely do I find that the resulting photographs feed my soul.

PROMOTER: I've created my share of headshots or promo photos but they just don't excite or interest me for long. Because of that, the Promoter approach is my least favorite of the types. And this isn't because I'm not good at it. I've learned the techniques and refined my skills. But the results don't speak to me, and after a few years of trying to like headshots, I gave up and came to terms with the fact that promotional portraits aren't my thing.

PLAYWRIGHT: I admire how the Playwright portrait photographer creates elaborate sets and scenes, and I really enjoy watching other photographers work in this way. Watching photographers create such strong and narrative-filled portraits is inspiring. To me, examples of Playwright portrait photographers are Chris Knight, John Keatley, Erik Almas, and, of course, Annie Leibovitz. While this work is amazing, I've realized that it's just not for me. Kind of like watching a snowboarder land a triple back-flip—it's amazing but it isn't something I'll ever do.

It took me years to figure out why the Playwright approach didn't draw me in. I thought part of the reason was that it is so elaborate and involved, and at the end of the day I'm a minimalist. But there was something more. One day, I heard a famous "Playwright" photographer talk about his approach. When asked about working with subjects, he responded, "I gave up creating photographs that say anything about the subject—there's no way I can do that. So instead I create a scene that says something about me." While I appreciated his honesty, I realized that his approach to portraiture was the exact opposite of mine.

ARTISAN: The Artisan approach resonates most with me. When I think of an artisan, I imagine a skilled craftsman making something by hand—a woodworker, ceramicist, weaver, or sculptor. I imagine this person working with natural, earthy materials to build an artistic, functional, one-of-a-kind object. I love the fact that artisanal crafts cannot be mass-produced, and

that's exactly why I enjoy photography so much. Whether it's a handcrafted guitar or hand-carved spoon, artisanal crafts have more depth and soul than something built by a machine. They speak deeply to me. And this is exactly why I like this type of portraiture so much. For me, it's all about thinking, directing, and working like an artisan.

Now it's your turn. Take a moment and reflect on which styles resonate with you and which styles irritate or annoy. If you've ever had your portrait made, what type of style did you like or dislike? Keep in mind that your reflections and conclusions do not have to be mutually exclusive—you might be a mix of multiple styles. The key is to articulate and define your own approach. Once you do this, you have a foundation for creating better photographs and developing your own unique style.

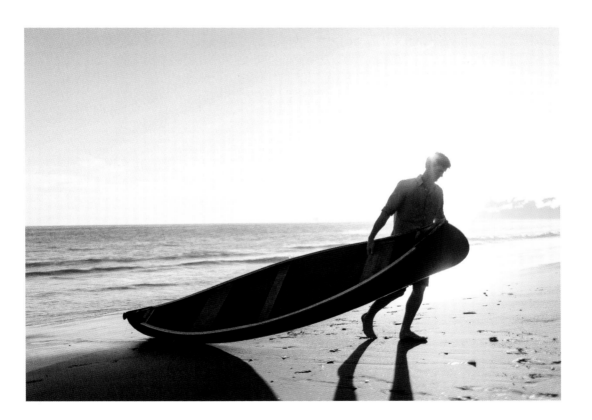

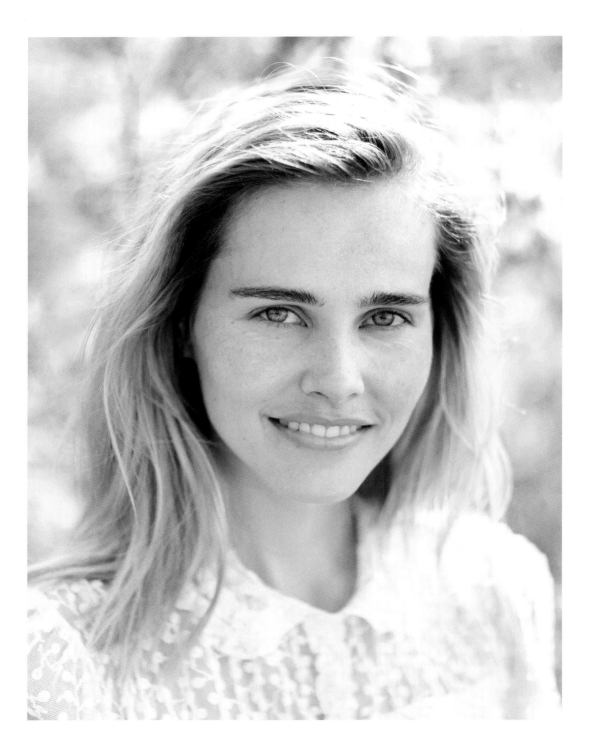

FINE-TUNE YOUR DIRECTORIAL STYLE

After having identified your approach (Journalist, Artisan, Promoter, Playwright, or some combination thereof), it's time to fine-tune how that approach shapes your directorial style. For example, as an Artisan you might be more precise or more rustic—are you more like the woodworker who makes violins or the woodworker who builds rustic furniture? Or you might be a Playwright who creates more classical Shakespearean narratives versus Modern Deconstructive tales.

Each of the styles can be accomplished in different ways; this is where the fine-tuning comes in, and it is often informed by your own temperament, personality, and interests. For example, your directorial approach might be calm, quiet, and kind while someone else with a more gregarious personality might approach directing with a sense of fun, adventure, and charm. The main point is to develop a sense of self-awareness, then use your natural gifts so you can direct and connect with your subjects with a technique that is authentic to you.

Take a few minutes and sketch out your own particular style—whether it's your current style or what you aspire to do in the future. If it helps, use adjectives, metaphors, and analogies to describe your approach. For example, I like to think of myself like this: a soulful artisan woodworker, who carves one-of-a-kind objects with custom hand tools.

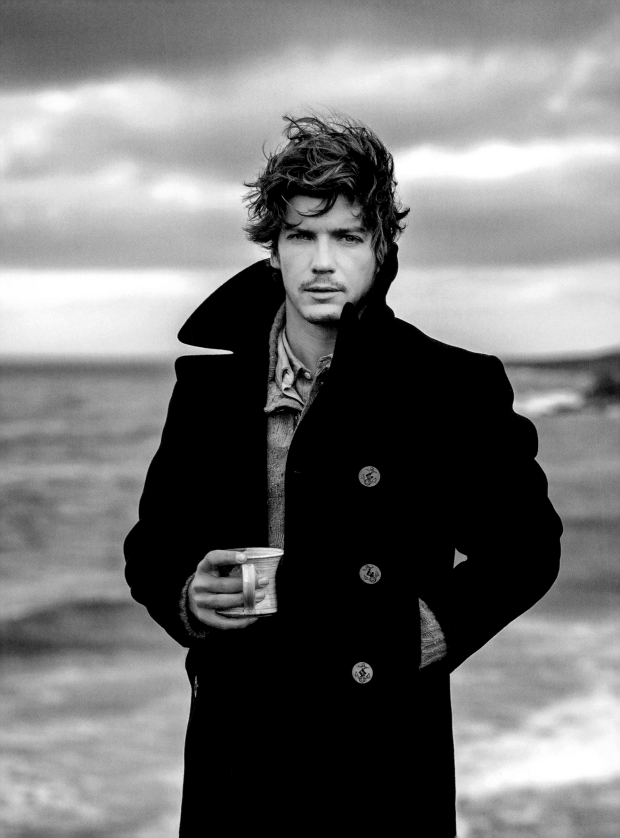

22

PRACTICAL
POSING TIPS

*Always be a first-rate version of yourself
and not a second-rate version of someone else.*

—JUDY GARLAND

If there is any word in the photographic vocabulary that makes me cringe, it's *posing*. This is mostly because I grew up as a kid in California who liked to skateboard and surf, and throughout my childhood the term *poser* was applied to the kid who dressed like a surfer/skater and acted like a surfer/skater—but who didn't surf/skate at all. In other words, posing or being a poser meant you were a fake. And for a while, I was mostly a wannabe surfer/skater kid who was a poser that desperately didn't want anyone to find out.

DECADES LATER, when I started reading books about photography

I skipped the chapters on posing because all the poses looked contrived. When I finally learned a few posing tricks, I hated using the term "posing." I preferred to think about it less as a pose and more as poise, posture, or presence. On top of that, as I started teaching I saw so many students try to make good photographs by relying too heavily on having their models assume a good pose. The resulting photos may have been posed well technically, but the photographs felt empty, hollow, or fake. There was something like a disconnect between the pose and the truth of who someone was, and those final images were technically perfect but devoid of soul.

While my issues with posing stem from being a surfer kid in California, we all have our own idiosyncratic issues with posing. The word is loaded with the meaning from our experiences and associations that we've picked up throughout our lives. Not all of these are bad, but they affect how we approach the topic. For example, you may be talented at posing men but not women (or vice versa). Or if you've done some fashion photography, you're probably pretty good at knowing the posing rules for fashion related to hands, legs, hair, etc. This knowledge is a great start, but it doesn't guarantee that your portraits will be any good. Fashion posing and portrait posing are completely different. Even within portraiture itself, posing varies from genre to genre. Portrait posing rules are different for editorial, commercial, beauty, and headshot portraits.

Whatever your background and experience, the first step to accomplishing better posing is to let go of your preconceived ideas so that you can approach authentic portrait posing with an open mind. In my own journey, as I've grown as a photographer I've had to continually let go and learn new ways to pose. That's because the type of posing you do depends on your skill level. Think of it like snow skiing. At first you learn to snow plow on the bunny slopes. But later, on the double black diamond, that snow plow technique won't really slow you down. By the time you are skiing at an advanced level, you need a new set of techniques to help you navigate the slopes in a fun and gratifying way.

What follows are the posing guidelines I have tested and developed through years of trial and error. As you read through these, think about how you might customize them to suit your own skill level, style, and needs.

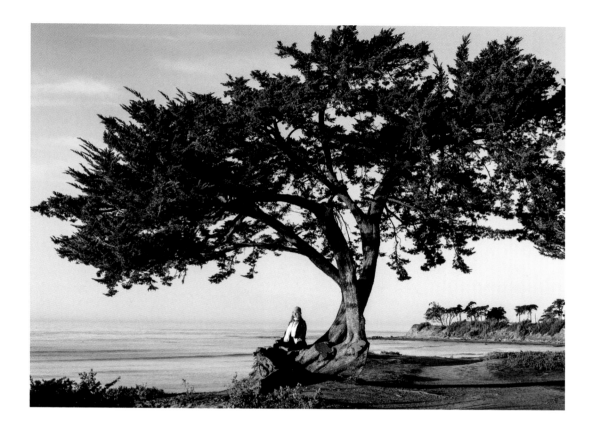

Sometimes a seated position might not be practical. When you are out on the streets, a subject can easily feel excited, nervous, vulnerable, and exposed. That's why most subjects fidget, bury their hands in their pockets, or stand in an awkward and uncertain way. For many people, the same thing happens with public speaking, and speaking coaches tell nervous presenters to find a way to feel less like they are completely exposed. They have the speaker hold a slide clicker, as it gives a sense of security, or they put a lectern on the stage so the speaker doesn't feel so vulnerable.

The same advice works for posing. Rather than having your subject stand in an open space, ask her to stand near a tree, railing, or wall—being close to such an object or structure reduces that feeling of being exposed. Or ask the subject to pick a leaf or flower and hold it in her hand; even if that object isn't in the photograph it can help put the subject at ease. You can also have the subject sit down on some steps or lean against a wall, but when they lean, make sure they are not squishing themselves into the wall. Coach them to slightly graze the wall versus burying themselves in it. One way to do this is to ask the subject to stand close to the wall and then lean on the back edge of their shoulder. The closer you stand to an object, the less you tend to lean.

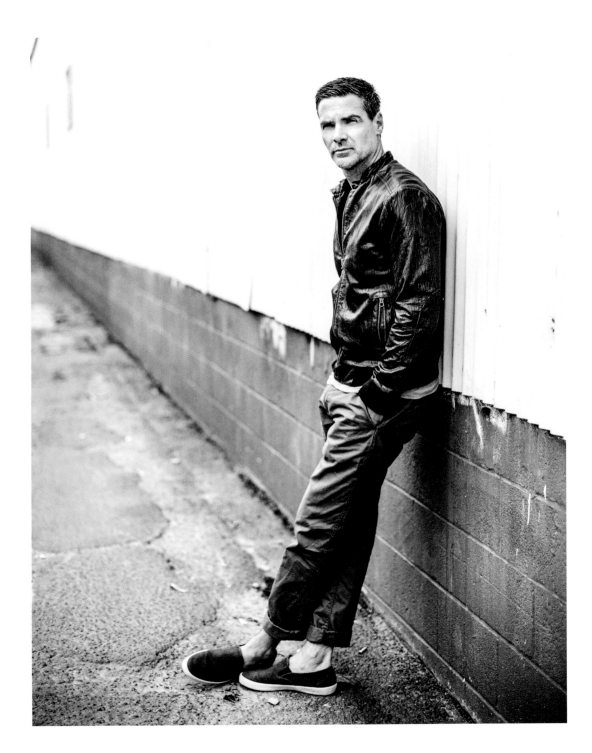

WHAT DO YOU DO WHEN THE POSING GOES "WRONG"?

Posing isn't a perfect science; it's more of an experiment to find what works best. Regardless of how skilled you are at posing, you will always end up asking your subject to pose in a way that doesn't look good. In those situations, keep things positive. Rather than criticizing or expressing even the slightest negative response, say something like, "Cool. That was interesting. Now let's try this...." In other words, don't ever betray your own disappointment or frustration because your subject will assume it's their fault. By taking this positive approach, you will be able to get in a groove and create some really good looks.

Even when the posing is going well on a shoot, eventually I know that, at some point, the quality of my posing direction will drastically decrease. This happens because we loosen up and relax and try out new ideas. Some of these ideas will work while others won't. Plus, nobody poses in beautiful ways 100% of the time. At first, I found this frustrating. Now I just let it happen and wait for the subject to relax while I change my lens (or employ some other made-up excuse). When I do this, the subject usually resets their posture to a more natural stance. Once I see that, I ask them to stand or sit still, and I capture that look. Many times, this "reset" pose is better than anything I could have come up with myself.

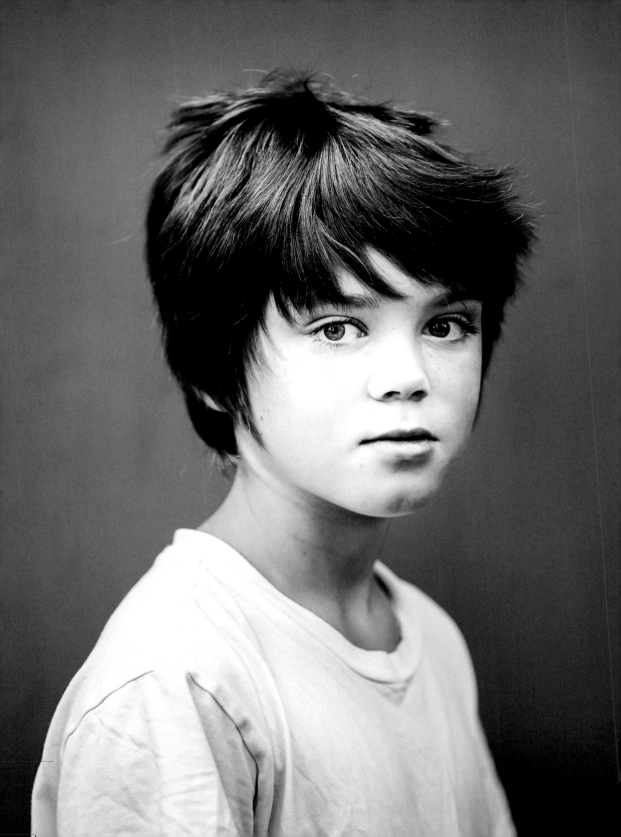

23
CONNECTING WITH THE SUBJECT

Our own life has to be our message.

—Thich Nhat Hanh

The most important part of direction isn't telling someone how or where to stand—that's easy. The real goal is to connect with the subject in a sincere way.

Connection is critical because the camera causes most people to feel insecure. More specifically, when you point a camera at someone, it can elicit a surprising and sometimes primal response that resembles a fight, flight, or freeze response. The camera's presence brings to the surface a unique strand of self-consciousness to which even the best-looking and most accomplished subjects are not immune.

THE CAMERA
amplifies insecurity, increases self-doubt, and uncovers buried fears we might have otherwise been hiding in our ordinary day-to-day lives.

And this amplification can give way to a feeling of awkwardness and a touch of dread, resulting in a subject that stands blankly in front of the camera not knowing what to do. This subject needs direction and feedback. And even the most confident subject can use a certain amount of feedback, input, or the chance to look in a mirror. Without feedback, most subjects (at least those of us who don't have experience modeling or acting) stiffen up or respond in an awkward way.

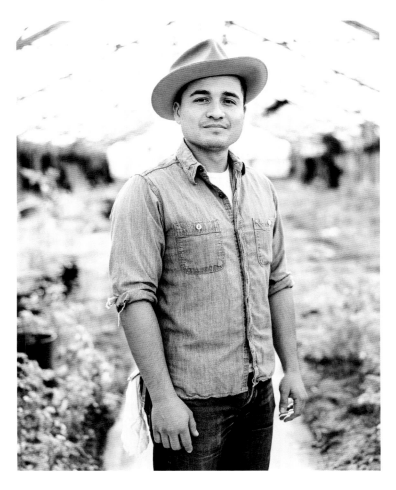

FREEZE OR FAKE

The most common and unphotogenic responses to being photographed are to freeze or fake it. Freezing up is just like being a deer in head-lights—the subject stiffens, tenses up, and forgets to breathe. You can often see tension in the face, neck, and shoulders, but it can also show up in other places. One person I photographed recently had a relaxed look on her face, yet had slightly clenched fists—it looked like she was ready to punch me!

Before judging the subject who freezes up awkwardly, remember what it's like to be photographed. Freezing up is what I tend to do myself. For me, this response comes from not knowing what to do, wanting to look good, and then trying too hard. As I noted earlier in the book, my daughter recently saw a portrait of me and said in a mocking tone, "Dad, you always try too hard to look so cool. Loosen up." Wise words coming from my eleven-year-old.

The second most common response is to fake it. We've all heard the phrase, "Fake it 'til you make it": even if you don't feel confident, act like you do. At first glance, this may sound like a good strategy, but it doesn't work well for portraiture because it leads to exaggerated movement, posture, and posing. (As a side note, while faking it doesn't work well in portraiture, it can certainly work for other types of photography, such as fashion, beauty, and lifestyle.)

The problem with faking it is that most subjects try to fake it by acting like a model (or acting how they imagine a model would act). As a way to illustrate this, let me oversimplify and caricaturize what this might look like. For a guy, this might mean standing tall and stealthily flexing his muscles in an attempt to look strong, in control, and cool. For a girl, faking it might mean tilting the head, bend-ing the hips and legs, or imitating a pose she saw in a magazine. Often the female version of faking it is an attempt to look beautiful, sexy, or confident. Of course, this is an unfair gen-eralization—not all male and female subjects respond this way. But I offer these examples because they do happen frequently, and what-ever the nuance of the response, the point is that trying too hard doesn't work well in por-traits, as it comes across as contrived.

As another example, let's consider smiling. A smile is a good thing, but trying too hard to smile transforms something good into some-thing fake, which results in an unsuccessful shot. In portraiture, what we want most is genu-ine, authentic, and real. When the subject tries too hard, it makes accomplishing that really difficult. So what do we, as photographers, do? Give up? Resort to using a posing trick? Or maybe we shouldn't try to influence the subject at all? There has to be a better approach.

As I mentioned back in Chapter 1, I found a solution to this problem while sitting in on an acting class, and I think this solution is worth repeating here. The director teaching the class explained, "When acting, you have to feel the emotion, the scene, and the moment at 100%. But only give the audience 80%." He called this the 100/80 rule: feel 100% but only deliver that emotion at 80%. You can't overdo it or it feels insincere.

It's true, right? Too much emotion equals bad (and insincere) acting; too much makes it look forced and fake. Of course, too little emotion equals dull acting. Finding balance is what makes acting such a difficult art form. The best actors take emotion and expression right to that edge of believability, but don't go over it—that's what makes their performance so engaging and real.

It's the same in portraiture. Forced poses and exaggerated expressions lead to shallow and awkward frames. That's why our job as the portrait photographer—who directs and connects with the subject—is to help the subject be expressive in a natural way. And this is where the art form comes in. Directing and capturing a natural look is a challenge because of how self-aware, self-conscious, and insecure we all become when a camera is pointed our way.

THE LOOKING-GLASS SELF

Once, I had a small role as an extra in a friend's film and was tasked with walking across the scene. I was comfortable and at ease until "Action!" was called—the moment I started to walk it was like I had forgotten how to move in a natural way. I became so self-aware and self-conscious that my walk looked awkward and fake.

The social psychologist Charles Cooley has an explanation for why I walked in such a self-conscious and unnatural way. In his early 1900s landmark research he explained, "We define ourselves through our perceptions of what others think of us." Cooley called this the "looking-glass self." (At the time, the term looking glass referred to a mirror.) He used this concept to explain how we develop our own sense of self-understanding through social interactions. In other words, we look to others and imagine how they see us, and their opinions act like a mirror, which affects how we think of ourselves. This happens regardless of how strong our identity is—what others think of us matters. When I walked across the scene, I was so worried about what others thought that I couldn't walk in a natural way.

The "looking-glass self" offers an explanation for why we worry about how we look and why we dress a certain way before a date or job interview. It's also why some people have an alcoholic drink in social settings. Worried what others think and wanting to make a good impression, some reach for something to calm the nerves. Whether we're self-conscious about how we look or how we walk, we're all self-conscious to some degree. The amount of our self-consciousness depends on the circumstance and who's "watching us perform." The more out-of-place we feel, the more nervous and self-conscious we become. Consider wearing a swimsuit at the beach versus wearing one on a stage—the context and audience act like a mirror that defines how self-conscious we are in each situation.

A little bit of self-consciousness is normal, but too much limits our ability to enjoy the moment, express ourselves, and be true to who we are. When we become overly self-conscious, we start to inflate the importance of what others think, or at least what we think they think. This leads to worry, fear, and feeling unsafe. You might say that self-consciousness and fear go hand in hand, because when we are self-conscious we are afraid: afraid of being judged, afraid of looking like a fool, afraid of not measuring up. But when we feel safe, loved, encouraged, respected, and protected, our best self shines through. When we feel safe, we become more willing to take risks, be vulnerable, go deep, and have fun.

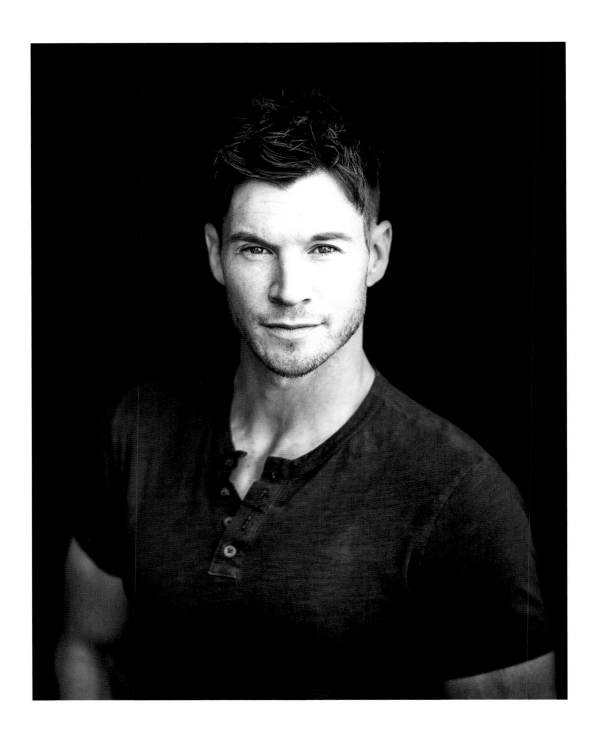

THE PHOTOGRAPHER AS MIRROR

Your job as portrait photographer is to create a safe place where your subject can let their guard down. And creating a sense of warmth and safety has less to do with the physical environment and more to do with you. It begins with your own internal state and how comfortable, confident, and at peace you are with yourself. Because in portraiture, the photographer acts like a mirror for the subject—not just in posing (as mentioned earlier), but emotionally as well. If you are at peace, then that feeling reflects back to your subject as well.

It's like how John Steinbeck described Dr. Ricketts in *Cannery Row*: "Being at ease with himself put him at ease with the world." What portrait subjects need more than anything else is a sense of ease, safety, and peace. That's why one of my top goals as a photographer is to be like Dr. Ricketts. I want to be the person so at ease that it's contagious to others.

Becoming someone at ease is a journey that begins within. It starts with a desire to be so at peace with yourself that your internal state reflects back to the subject and conveys a sense of kindness, acceptance, and love. Of course, most of us don't always feel self-confident and at ease. Plus, the difficulties of daily life act like dust that block and obscure what we reflect back to our subjects. So becoming a better portrait photographer requires taking the time to wipe the surface clean so that we are able to emotionally reflect back and show our subjects something they have never seen—a warm-hearted look at who they are. This is one of the reasons why I find portrait photography to be less of a craft and more of a calling—what the world needs more than ever is people who share, project, and reflect love into others in an authentic way.

Being a mirror like this is one way we can build others up, and science has demonstrated it to be an immediate and effective way to build rapport. As behavioral scientists explain, the nonverbal act of "mirroring" is one of the quickest ways for two people to connect. Nonverbal mirroring is referred to as isopraxism (this word comes from the Greek *iso-*, or "same," and *praxis*, "behavior"). The neuroscientist Paul MacLean was the first to popularize this idea in the mid-1970s. Back then he used the term to refer to unconscious imitation in animals and humans. In animals, the concept explains phenomena such as the simultaneous head-nodding of lizards and the movements of schools of fish. In humans, isopraxism explains why certain postures, gestures, facial expressions, and bioelectric activity sync up with those with whom we interact. It also explains why yawns are contagious and why seeing someone smile makes us feel good.

Since MacLean introduced the term, neuroscientists have discovered that isopraxis is tied to activity related to our mirror neurons. For example, when we see someone smile, our mirror neurons fire up, which ignites a blaze of neural activity that elicits the feeling of what it's like to smile. Often, if the connection is strong enough, this activity leads us to reciprocate the

smile ourselves. In short, isopraxism explains why seeing someone with a bright and beaming smile makes us feel a certain way. Of course, this works for other emotions, too; if you observe someone who is nervous, you might feel that anxiety, too. Finally, the extent to which two people mirror each other's emotions or behavior is determined by their level of affinity and trust.

When you look for it, you see isopraxism everywhere. Even babies practice it—when a mother smiles, giggles, or arches her eyes, her baby does the same. You can also observe this kind of mirroring in courtship between lovers or in a conversation between close friends. When two people have a high level of affinity and trust, mirroring becomes visibly displayed. Yet still, most of this kind of mirroring happens subconsciously and isn't done intentionally.

But that doesn't mean you can't practice intentional physical and emotional mirroring in order to reap its benefits. Many communication coaches (and a few portrait photography teachers like myself) have picked up on the power of mirroring and now teach this as part of their craft.

The first time I read about isopraxism was in Joe Navarro's book *What Every Body Is Saying*—a highly recommended book for anyone interested in becoming better at identifying and using nonverbal communication to connect with others. Navarro is an ex-FBI agent and global expert in nonverbal communication. In his book, he discusses a wide range of interesting aspects of nonverbal communication—everything from how to detect liars to why thumbs, feet, and eyelids reveal so much about moods and motives. It is a very interesting read, especially for us portrait photographers.

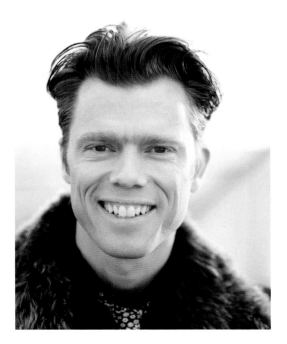

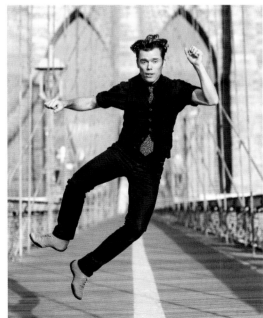

Here's one example. Navarro explains, "When we are excited about something or feel very positive about our circumstances, we tend to defy gravity by doing such things as rocking up and down on the balls of our feet, or walking with a bit of a bounce in our step." First off, this is interesting nonverbal behavior to observe in yourself and others. Second, as a portrait photographer, you can use this in a specific way. Let's say you want to create a more positive portrait and you want your subject to feel more positive about the shoot. In that case, you might adopt this type of "gravity-defying behavior" yourself or direct your subject with this in mind.

Regarding isopraxism, Navarro explains that it is an indicator of affinity, intimacy, and connection. For example, observing a couple on a date sitting down at a restaurant, the positions of their feet and legs reveal how well the date is going. If the feet and legs are mirroring, it means the couple likes each other and the date is going well. Mirroring is a way to connect without words.

The legendary photographer Richard Avedon was well known for using mirroring in his portrait and fashion work. If he wanted a model to leap through the air, he would leap himself. And much of the direction and feedback he gave to his models and portrait subjects was expressed physically and emotionally through mirroring behavior. Famously,

in his series *In the American West,* he talked very little to the subjects but assumed a pose and stared. Not knowing what else to do, the subjects reciprocated and mirrored the posture back. Without using almost any verbal posing direction, Avedon created some of his most powerful work.

Most of us mirror behavior without being consciously aware of it. But we can learn from people like Navarro and Avedon so that we, too, can use mirroring intentionally in order to connect, direct, and build rapport.

One way you might try this is by matching the way your subject stands, tilts her head, talks with her hands, or crosses her legs. Basically, any gesture or behavior that matches the subject's posture, behavior, or tone serves as a way to mirror and connect. And you can combine this behavior with listening and providing positive feedback so that the subject picks up on your good vibes as well. You might ask the subject a question, mirror the subject's behavior while you actively listen, and respond with a head nod and smile. So it's not just that you mirror like a robot, but that you do so with the sense of contributing your own positive influence as well. You may be pleasantly surprised to find that your positivity is mirrored back—it usually is. Good vibes and good intentions are contagious, especially when shared with the aim of creating art, connecting, and making the world a better place.

GOOD VIBES AND GOOD INTENTIONS ARE CONTAGIOUS.

ACTIVE LISTENING

As mentioned above, mirroring and positivity aren't the only essential ingredients for making a connection. Active listening is another important component. When you actively listen to your subject, you demonstrate that you are present, engaged, and truly hearing what's being said. This kind of listening creates a strong bond.

Ways to indicate you are actively listening include providing attentive and expressive eye contact, visualizing what is being said, leaning forward, using a head-tilt (a sign of affinity), showing engagement and appreciation with short responses like "Hmm," "Really," "Okay," and reflecting back or summarizing what has been said. You can also ask clarifying questions to encourage more sharing. Be sure to ask questions that the subject will enjoy answering.

Active listening is discussed in almost every communications book. Yet strangely, it's rarely mentioned in photography books. I think this might be because active listening requires you to put your camera down (figuratively, at least), which is usually the last thing photographers want to do! We are more comfortable giving posing instructions, clicking the shutter, and making frames. We are more comfortable hiding behind the camera and lens. But to make strong and revealing portraits, you have to listen with your ears, eyes, heart, and soul. When you truly listen like this, it forces you to slow down, and it opens your eyes to see the truth, light, and humanity that was hidden before.

When I taught at the Brooks Institute of Photography, I had the opportunity to meet a handful of the world's best photographers when they would visit the school for gallery expositions and presentations. Each time a famous photographer visited, I went out of my way to get to know him or her in a one-on-one way. The photographers who interested me most were always the portrait photographers.

What surprised me most about them was how gifted they were at putting people at ease. While other photographers (fashion, commercial, and travel photographers) sometimes came across as overworked, stressed, preoccupied, arrogant, or abrasive, the portrait photographers always had this warm, kind, and curious aura they projected wherever they went. Whether they were talking with the gallery staff, a student, or the waiter at lunch, they brought out the best in those they spoke with, including me. The way they listened and asked questions made you feel important. After just a short time, these photographers felt like old friends, the kinds of friends you'll have your whole life. And the proof of the genuineness of their spirit was the friendship that lasted long after they left the school.

When I later visited with these famous photographers who lived in different parts of the world, it became apparent that what makes a good portrait photographer is not just vision, composition skills, or knowing how to use lights. A good portrait photographer is someone with a deep and inquisitive soul who values people in an honest way. Ultimately, the skills that most directly affect the portraits a photographer creates have little to do with gear or specific photography techniques and everything to do with who the photographer is and how they connect with their subjects in ways that bring out their best and put them at ease.

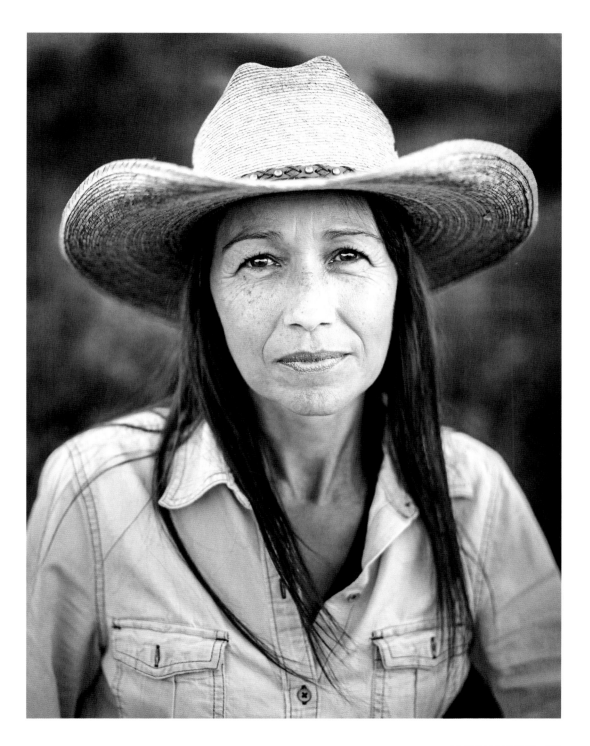

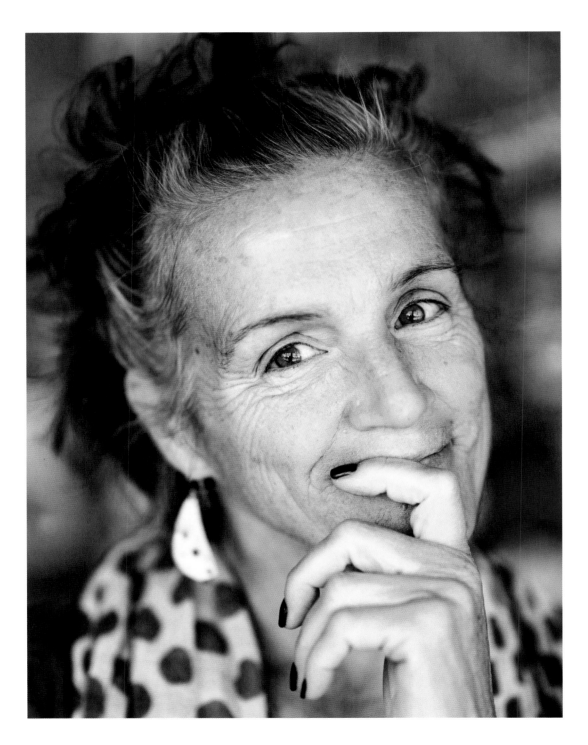

RECENTERING

Another way we can help others be at ease is to visualize and feel what it means to be your authentic self. For me, I've found that I am most alive, most secure, and most comfortable when I operate from a place of authenticity. I like to think of the authentic self as the best version of who I am—my core and the center of who I was designed to be.

But it's easy to stray from that "authentic self" anchor point, and the camera doesn't help. Whether we're the photographer or the subject, sometimes the camera pushes us to different extremes, and rather than being authentic, we come across as apathetic or aggressive. Instead of confident, we seem insecure or arrogant. We all respond to the power and presence of the camera in different ways. Regardless, in front of the camera, most subjects project an image of their selves that isn't 100% real. That's why our job as portrait photographers is to look past insecurity and arrogance and, through recentering ourselves and our subjects, find the stronger personality traits that lie within.

Once I was photographing an elite athlete and the look he was giving the camera was goofy and dull. I think he was trying to appear "relaxed," but it came off looking like he was aloof, disengaged, and bored. Rather than being discouraged, my job was to recenter him so that his authentic self shined through.

When it comes to recentering, I've found that it helps to acknowledge and visualize the authentic self at the core of each of us. The point isn't to visualize what exactly the final portrait will look like—that's impossible, as the authentic self is an invisible and ever-changing target that can't be pinned down. Instead, the aim is to visualize that at the center of each of us is that core. And in authentic portraiture, that core is better than anything else. When you start capturing portraits and sense you are getting closer to the authentic core, let go of any worries about posture or posing and just keep digging. While you dig, pay attention to your instincts because the authentic core is something you find only with a mixture of intuition, optimism, and trust.

If you are uncertain whether you are getting close, stop checking the images on the back of your camera and start paying attention to the feeling in your heart. When you get closer to the authentic core, your heart will let you know and you will feel a sense of excitement and reverence coursing through your veins. In those moments, time slows down and your vision becomes crystal clear. In this "slowed down" time you might suddenly see a split-second glance, the perfect position of your subject's head, or a fleeting moment of light and soul aligned in a perfect way. When this happens, your privilege and responsibility is to press the shutter with hope, gratitude, and grace.

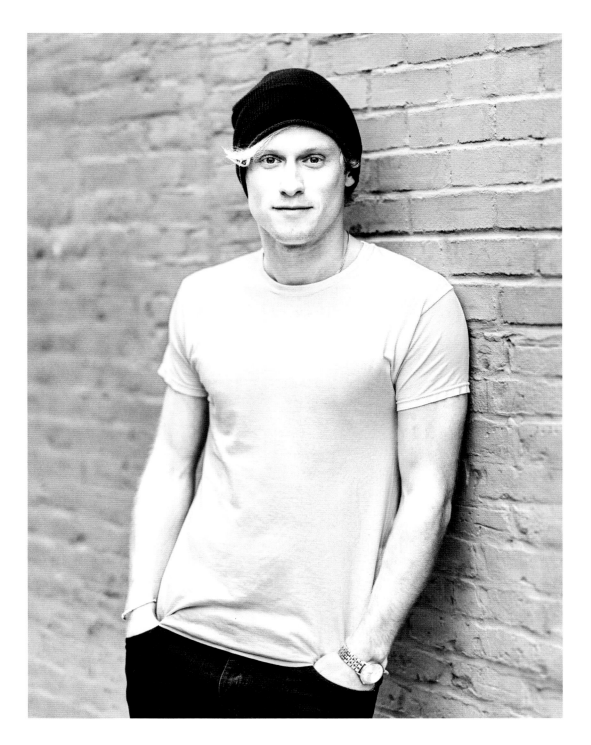

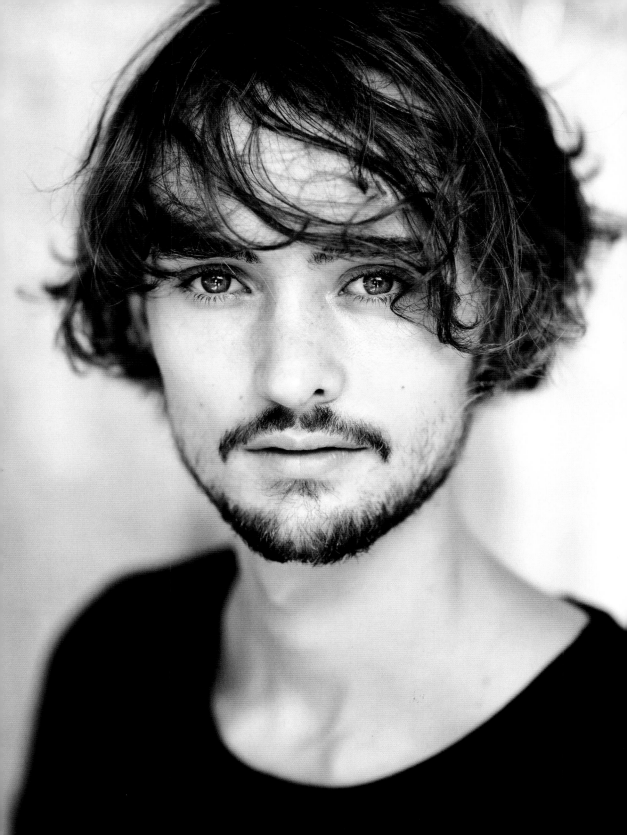

24

UNLIKELY INSPIRATION FOR CONNECTING

It doesn't become an art until your soul goes into what you do.

—Buck Brannaman

Connecting and directing isn't something that comes naturally for most of us; it's an acquired skill. Sure, some of us are better at it than others, but all of us have room for improvement. When I first started out, I hid behind the camera and didn't provide much feedback or direction—I didn't know what to say, and I was too nervous and too worried about my camera settings to focus on the subject in a meaningful way. Fifteen years later, I still get nervous during a shoot. If you get nervous like me, or just want to get better at connecting, I'd like to share a couple skills that will help you.

THE SKILLS I want to highlight come from two unlikely sources—the first deals with a few surface issues, and the other offers us something profound. The first set of skills comes from a man who was born into poverty before becoming famous for the public speaking techniques he taught at the YMCA. Dale Carnegie began by teaching communication in a small dingy classroom but eventually went on to teach millions across the globe. His 1936 book, *How to Win Friends and Influence People*, has sold millions of copies and become a classic self-help communication book.

Some find Carnegie's approach trite. A common critique of his book goes something like this: "It's an overly optimistic, simple-minded handbook on how to exploit friendship for the sake of personal gain." But I think this critique has less to do with the book and more to do with the reader's approach. The way I approach this book (and most books) is to look for the hidden gems. No book provides all the answers, so when I read a book I look for the ideas that stand out most and ask, "How do these relate to me?" When evaluating a book, I keep in mind Henry David Thoreau's words: "A truly good book teaches me better than to read it. I must soon lay it down, and commence living on its hint. What I began by reading, I must finish by acting." Carnegie's book provides plenty of ideas when it comes to learning how to better connect and direct portraits. If you apply these ideas in the right ways, it can lead to solid results.

25
THE FOUR-STEP APPROACH

Smile, breathe, take it slow, and live a happy life.

—Johnny Lung

The art of authentic portraiture cannot be distilled into a series of simple, easy-to-follow steps. As we've seen, it takes multilateral growth to become better at the craft. We have to learn how to work better with light, posing, directing, connecting, and more. Building upon what we've already talked about, I have found there are four additional strategies that I employ in almost every portrait session I do. These four steps are the "secret sauce" that I use every time I shoot. And I'm not sharing these in an attempt to create a catchy way to make portraiture easy. I'm sharing them because they work. They are: Questions, Movement, Deep Breathing, and Eye Contact.

1. QUESTIONS

I've always been interested in questions, but became even more so when I met Joyce Tenneson about a decade ago. Joyce is a photographer who created one of the best-selling photography books of all time, *Wise Women*. When making this book, Joyce photographed more than 300 women in a short amount of time. She created all of this work as a personal side project while doing other commercial jobs. When I met her, I asked her how she connected with so many different people in such a strong way.

"It all hinged on asking the right questions," she explained. When first meeting a subject, she began the sitting with a question such as, "What matters most to you in life?" or "Who are the most significant people in your life?" or "What is the event in your life that most dramatically shaped who you are?" With these questions, she cut to the chase and got the subject talking about what mattered most. And it was this kind of "wisdom" that filtered into the frames.

Upon hearing this, something clicked for me, and I shifted my focus away from capturing a "look" and toward capturing the story of who someone is. Once I had that aha moment, I started devoting energy to learning how to ask good questions. I began to listen, look, and search for questions, and I began to test out what I found. Here are a few of my discoveries.

Good questions during portrait sessions work on so many different levels. First and foremost, they help the subject think of something other than the awkwardness or anxiety of having their portrait made. In this way, good questions act as diversions. I think that's why dentists ask you questions while they are doing your dental work—they are trying to get you to think about anything other than having your cavity drilled.

Second, questions can trigger us to relive experiences and emotions from the past. For example, if you're asked to discuss the happiest, saddest, or most difficult moment in your life, it changes what you think about, how you feel, the look on your face, and the energy you project. When we retell a story from our own lives, we reimagine and relive that moment as we tell it. So I try to ask questions about the subject's life, especially when the subject or myself is nervous, such as in the following example.

I was waiting nervously on the set, as 15,000 students from around the world tuned in to the live broadcast of a photography course I was teaching. I was just about to meet the subject, and I wasn't sure how I was going to pull this off. The subject was a complete stranger, and all I knew was that she was an accomplished businesswoman. I don't know much about business, but I knew I would start with a few questions.

As the subject walked onto the set, I was struck by how poised and professional she appeared as she walked. She was clearly a confident and accomplished person. As far as a portrait goes, I wasn't very interested in capturing a business headshot or promotional portrait, so after a few small-talk questions, I asked about her family. Right away, her face lit up and she talked about her recently born daughter. Suddenly, all of the professionalism melted away; underneath that shell was a beautiful and warm-hearted soul. Her face beamed with a bright smile and her eyes sparkled with the love only a new mother can feel (opposite page).

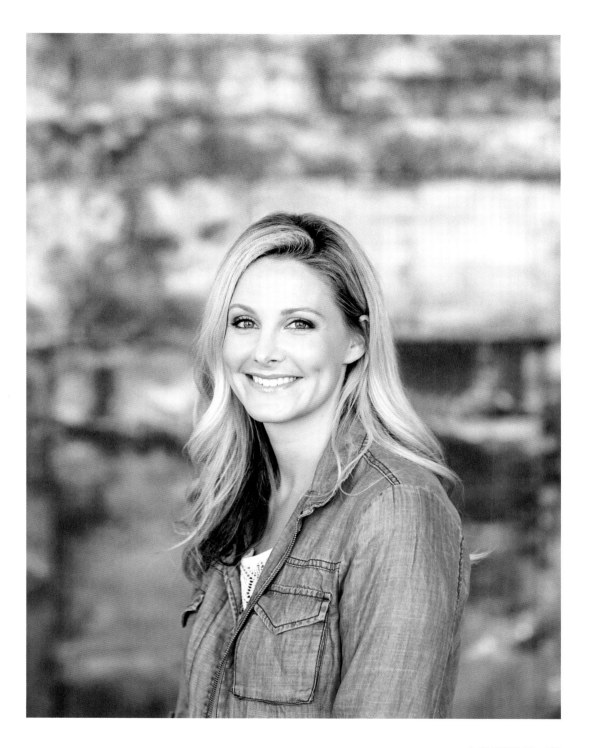

Good questions can be something you stumble upon (like in the previous example) or they can come from a premeditated idea. Some questions don't even need to be verbally answered for them to elicit a response. For example, you might want to try to encourage a warm expression from a subject who doesn't want to have her portrait made. Knowing this can be a big advantage, like when I photographed my daughter Elsie. She wasn't too keen on the idea so we brought along our dog, Daisy, and I said, "Don't you just love Daisy? How about if you give her a hug?" Elsie gave her a huge hug and smiled in such an adorable way.

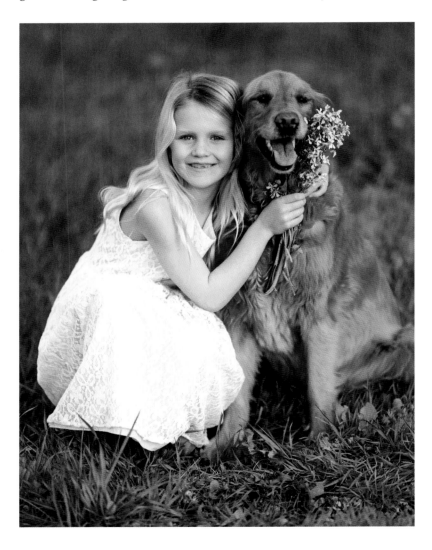

Questions such as these are keys that unlock the inner life of who someone is. The right questions unearth, uncover, and reveal. The wrong questions bury the inner truths with more dirt. But even if you ask a bad question, usually the soil can be cleared away. For example, if you start with an uninteresting question—like "How are you doing?" or "How about this weather?" or "What do you do?"—and you get a typical, short response, you can still find a way to dig deep. That's exactly what great conversationalists do.

Those who excel at making good conversation often begin with the ordinary and quickly develop it into something much more compelling. With this approach, you might begin by asking, "How about this weather?" and then follow it up with a better question like, "Was the weather like this where you grew up?" This could lead to more dialogue: "So you grew up in Kentucky. Well, how'd you end up in New York?" These strings of questions have the potential to open up the subject about their life story. And what you hear might be fascinating—all because of a dull question about weather.

That's what happened to me with Alex (below). What began as a simple question led to learning that he was an extremely successful banker in Paris who hated his job and lost his passion for everything he had worked so hard to achieve. After realizing the life he was living didn't match his dreams, he left and has never looked back.

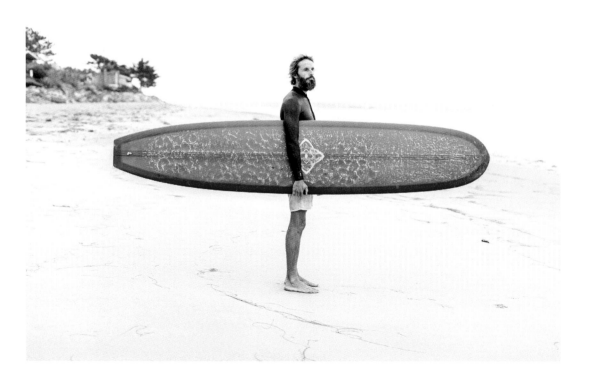

If you ask questions in the right way, they can have a cumulative effect—what starts off simple can often lead to the profound. Still, there are a few guidelines that help you have a strong start. This means staying away from questions that have yes/no answers, and instead looking for more open-ended ways to engage. Often I'll begin with, "So, what's your story?" This is about as open-ended as it gets, and it provides the subject an opportunity to answer however they please. For some, this question is too vague and too open-ended; subjects sometimes ask, "What do you mean?" I respond with some clarity but not too much. I might say something like, "I mean, where are you from, what are your interests, how'd you end up here? But really it's an opened-ended question. I'm just curious to know more about you."

After having started off in the right way, ask more questions. Very rarely do your first questions lead very far. That's why you need to ask follow-up questions to guide the conversation along. Three different types of follow-up questions are worth giving a try, and I categorize them as questions that qualify, connect, or dive deep.

A qualifying question—such as "Can you tell me more?" or "What do you mean?"—shows that you're interested and invites your subject to talk more.

Next, ask questions that create connections to other topics; this gives the subject something to build upon. For example, after asking someone about their childhood, you could then ask, "How did that experience relate to what you do

now?" or "What were your favorite books when you were a kid?" This type of question seeks to make the leap between two topics (childhood and current work, or childhood and books) and connect them together.

Finally, ask questions that get at the deeper meaning of things. Often these questions begin with "Why?" An initial conversation might begin with the question, "What do you do?" The response: "I'm a portrait photographer." To go deeper, you might ask, "Out of all the different things to photograph in the world, why portraits?"

If all this talk about questions has piqued your curiosity and you want to learn more, a great place to start is to study and listen to those who ask questions for a living. You might listen to Terry Gross, host of NPR's *Fresh Air*. Gross was recently referred to as "the most effective and beautiful interviewer on the planet." Over the course of 13,000 interviews, she's made an art out of asking questions. You could also watch *The Tonight Show with Jimmy Fallon*. Gross and Fallon ask extremely different kinds of questions and get different results.

Gross asks deep and probing questions that often result in her guests sharing intimate insights. Fallon's questions create likeability and often lead to fun and funny moments. What makes Fallon so likable is his knack for asking questions that create common ground. Fallon's questions also establish rapport, which helps his guests open up in fun and unexpected ways—watch an interview clip online and you'll see what I mean.

26

COMPOSITION

Exists no miracle mightier than this:
to feel.

—EE CUMMINGS

Composition is to photography what syntax and sentence structure are to poetry, what musical notation is to song, and what food presentation is to a chef. Photographers use composition to arrange, express, and create. The composition establishes the rhythm, feeling, and flow of a photograph. It creates a sense of balance or imbalance, clarity or complexity, awe or angst. It conveys the narrative and purpose of a photograph.

A PHOTOGRAPH'S composition is fixed, boxed in by four inflexible sides. So "thinking outside of the box" isn't something that applies. With photography, it's more like, "Think within the box and show nothing else." Great compositions show us a limited point of view.

The best photographic compositions embrace the constraints of the rectangular frame and limited space. Almost like a good poem that's made up of just a few words. In poetry, it's not your verbosity that wins. What the novelist says in 20,000 words, the poet says in 10. And with such few words, a line of poetry can unlock access to deep feelings and ideas.

The art of poetry is always about paring things down, and the art of photographic composition is the same.

Because poems are so sparse, the best ones invite you to read them multiple times. The first reading helps you take in the structure and content. The second reading reveals a hidden inner truth. The third reading speaks directly to the soul. A good poem is something that you can (and should) revisit time and time again. Leaving you with more silence than before. Just like how the poet Billy Collins puts it: "The beauty of a poem can be measured by the degree of silence that comes after the last line."

It's the same with good portraits. They quiet us down and never grow old. The first glance catches our attention and draws us in. The second look reveals something we may not have noticed at first. The third viewing is when the portrait really begins to speak to us about something more than the subject, light, or look.

Photographic composition can be seen as either a simple tactic distilled into a set of rules or an art form that is nearly impossible to describe. I prefer the latter, and so I find it insightful to compare photographic composition to composition in other crafts and art forms. Sometimes photographic language falls short of what I want to say, so I turn to analogy and metaphor.

In classical music, composition is where it all begins. The composer selects a key, chooses notes, and then assembles the notes with directives for rhythm, cadence, crescendo, and tone. The resulting music hides all traces of the fight the composer faced in her creation. For to create, the composer must wrestle, wrangle, and revise all the notes until they are one seamless whole. No longer separate markings on the page, the notes become music that makes us think, feel, dance, and sing. The best composers hide themselves within their art—always present but never seen.

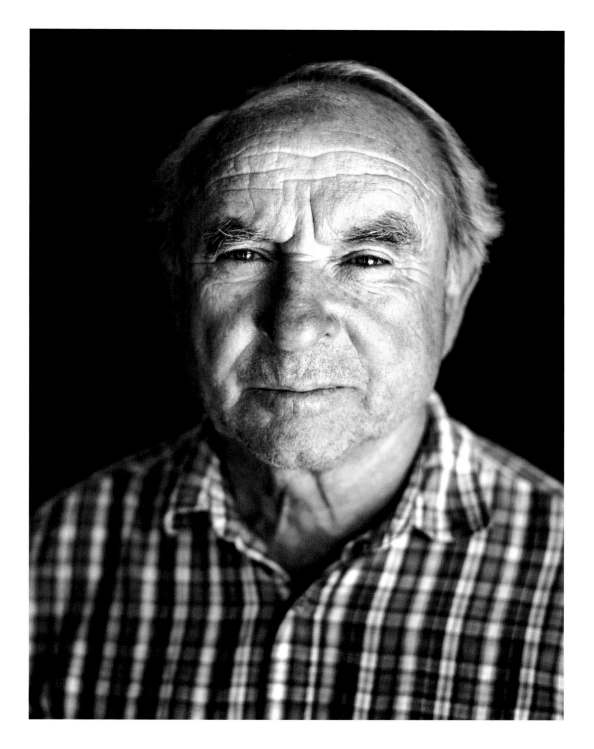

ROB

What do you do when you have a subject that hams it up, goofs around, or is nervous in front of the camera? First and foremost, let the subject be who they are. There's no use in forcing someone to try to be serious and deep. And typically, erratic or goofy behavior is an indicator of feeling nervous or unsettled. The best way to get someone to settle down is to be a little goofy yourself and shoot the photographs anyway.

That's what I did with the celebrated surfer Rob Machado. The first few photographs weren't great (below) but they were part of my process. After those photographs, I asked Rob to square off with the camera, look down, take a breath, and then look back at the lens. The resulting image can be seen on the opposite page. Sometimes you just have to go with the flow and then take a few decisive steps to create a strong portrait.

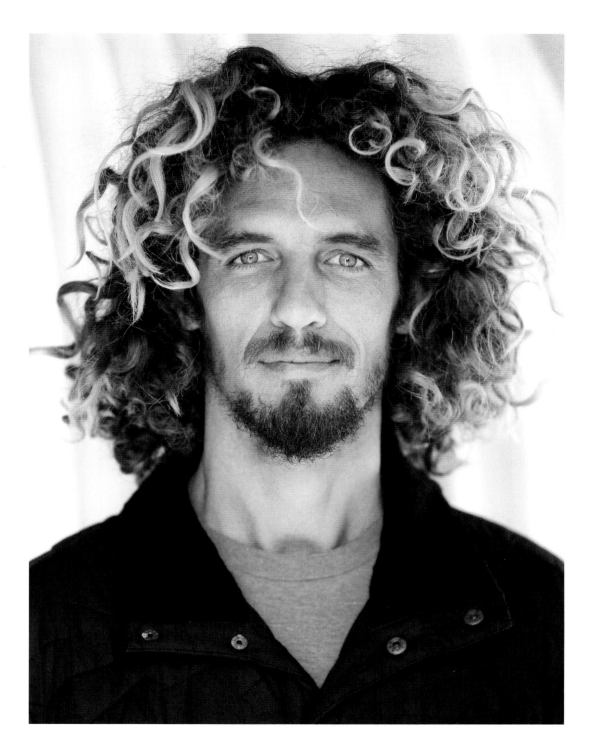

JACK

Jack O'Neill is often credited as the man who invented and popularized the modern wetsuit. As a surfer myself, I owe a huge debt to Jack. And the first wave I ever caught was right in front of his house. So when I had the chance to photograph him at his home in Santa Cruz, I was incredibly excited. Jack had lost an eye in a surfing accident years earlier, and when I met him he was in his eighties. As my daughter put it, "He looks like a pirate," and I think she is right.

The shoot began with a conversation in his living room and I captured a few frames (below) but they seemed too casual. Having only a few minutes, I asked Jack if we could go out to his porch, which literally hung over the ocean below. I had him sit on a bench and look to the side, and I captured the frame on the opposite page. This shoot serves to remind me that sometimes the difference between mediocre and great is just a few steps away.

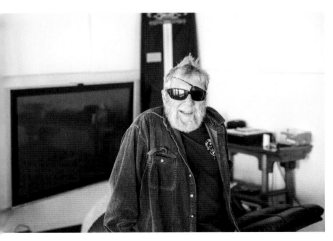

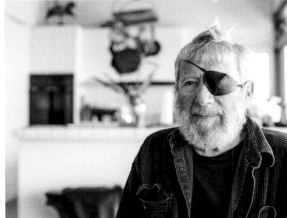

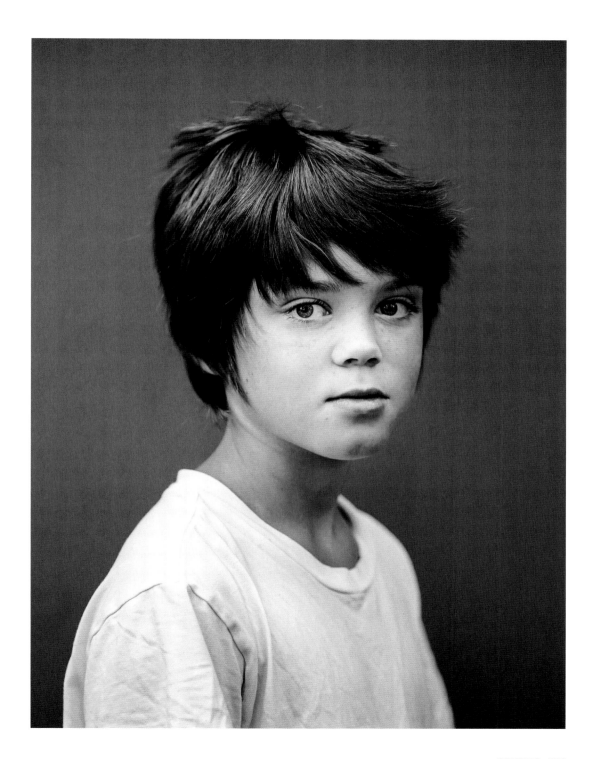

PART 07

STEPPING UP
YOUR GAME

28

THE OTHER SIDE
OF THE LENS

*We will only understand the miracle of life fully
when we allow the unexpected to happen.*

—Paulo Coelho

The camera can be a passport, but it can also be a shield. That's why so many of us hide behind it and say, "I'm just more comfortable behind the camera than in front of it." Behind the camera, we are safe and in control. We watch, listen, and observe without having to be vulnerable ourselves.

IN FRONT OF the camera, we are exposed, and our once impenetrable confidence melts

into mush. When even the most confident photographer steps in front of the lens, he or she feels a hint of awkwardness, uncertainty, and self-awareness that seems out of place. Having your portrait made is hard.

As portrait photographers, we know the lens acts like an x-ray device that sees past the facade and reveals what's hidden beneath the surface. We know how the process works. You might think we'd be more comfortable in front of the lens than a landscape or food photographer, but it isn't so. We may be experts at working with people to create meaningful, honest, and vulnerable frames, but it doesn't make a difference. Our expertise in vulnerability is about others, not ourselves. Asking someone else to be vulnerable is much less difficult than being vulnerable ourselves.

But the artist's path requires that we take the risk. In order to sympathize with, empathize with, and understand our portrait subjects, we must become the subject ourselves. That's the only way to step up your game and truly learn what it's like to have your portrait made, and thus, to know how to put your subjects at ease. This kind of wisdom can't be learned through a blog post, book, or online tutorial. It only comes from experience. We need to feel the discomfort, experience the emotional exposure, and grapple with the sense of uncertainty that happens when we stand before the camera and lens.

Unless you look like a model and have been photographed a lot, the only way to gain the experience of having your portrait made is to ask. You have to muster up the courage and ask a friend, family member, or stranger to create your portrait, and then you have to let go of control and let go of wanting to appear a certain way.

Before you begin, get in the right mindset. First, stop worrying about how you look. A portrait is not about how you look or what you wear. A portrait is about who you are at this specific stage in life. Next, lean into the difficulty, discomfort, and awkwardness and see it as an opportunity to learn. Take a deep breath and look back at the lens with intensity, integrity, authenticity, and resolve.

I have one photographer friend who refuses to have her portrait made. We've been friends for over a decade, and I've asked to capture her portrait more than twenty times. She has refused every time, and I get it—having your portrait made takes guts. But that's exactly why it can be a great opportunity to learn. When we do something difficult, it shapes our identity in an unprecedented way.

AWAKENING THE ARTIST WITHIN

When neglected, the inner artist drifts to sleep, but it's always on the ready to reawaken and come back to life. When the art spirit awakens, it changes the way we live. The painter Robert Henri put it this way: "When the artist is alive in any person, whatever his kind of work may be, he becomes an inventive, searching, daring, self-expressive creature. He becomes interesting to other people. He disturbs, upsets, enlightens, and opens ways for better understanding. Where those who are not artists are trying to close the book, he opens it and shows there are still more pages possible."

When the art spirit awakens, it changes how we live and how we see. Before you were a photographer, you might have seen an old homeless person as someone to avoid, but with camera in hand, that same person becomes a beautiful soul that you want to get to know. Artists always see the beauty in everything. I like how Vincent van Gogh described this in a letter to his brother Theo: "I see paintings or drawings in the poorest cottages, in the dirtiest corners." Awakened artists are driven to search for what others overlook as they keep flipping the pages of the book that everyone else wants to close.

Early in his own artistic journey, Van Gogh struck up a relationship with his cousin Anton Mauve, a famous painter at the time. Mauve acted as his art teacher, and the two became friends. But the friendship didn't last, as the two painters often came into conflict and clashed. Mauve's painting style was somber, dark, and realistic, while Van Gogh was using color and small dots in a vibrant and unprecedented way. Mauve didn't understand or see this new approach in a positive way—frankly, I think he thought Van Gogh was going off the rails. On top of their obvious artistic differences, their personalities also seemed to clash. It didn't affect Mauve much, but Van Gogh was deeply troubled by Mauve's dislike, disapproval, and disdain.

In a letter to his brother Theo, Van Gogh vented about a conflict with Mauve that really hurt. Van Gogh complained, "Mauve takes it amiss that I said, 'I am an artist,' which I won't take back, because it's self-evident that what that word implies is looking for something all the time without ever finding it in full. It is the very opposite of saying, 'I know all about it, I've already found it.' As far as I'm concerned, the word means, 'I am looking, I am hunting for it, I am deeply involved.'"

These words reveal so much about what it means to be an artist. It's a bit comical to think that someone "took it amiss" that Van Gogh, one of the most famous artists of all time, called himself an artist. So the next time someone takes aim at what you call yourself, remember that critics are nothing new, and they're often wrong, especially when it comes to creativity and art. The most important thing is to fight to keep your creative spirit alive. As Jack London wrote, "You can't wait for inspiration, you have to go after it with a club." The creative fight is real, and it often involves a white-knuckled search.

Van Gogh fought for his craft. He fought to find models, fought to find funds to buy supplies, and he fought to find validation for the art he made. He searched and painted with obsession and a reckless abandon, never willing to give in or give up. Sometimes he dug so deeply that he couldn't climb out of the pit he created. He worked to the edge of insanity and even admitted himself to an asylum to get help. His search continued until the day he died, and through it all, he never quite found what he was looking for. Some would consider this a failure, like the mountain climber who never reached the summit. But in art there is no peak. The only thing to conquer is the urge to give up, and in that, Van Gogh never failed. He constantly pushed himself and painted with a desperate vulnerability and honesty that still ring true today. Over a century since their deaths, Mauve is mostly forgotten while Van Gogh's masterful brush strokes live on.

Van Gogh's life and work illustrate that being an artist isn't easy, but that's beside the point. Nothing good in life comes without giving something up. This is especially true in art, which requires that we surrender ego, embrace vulnerability and honesty, and learn how to feel deeply. I've noticed that the great artists sense and feel life in more intense ways. Almost as if they have extra sensory glands that pick up on what the rest of us don't see, touch, taste, or feel. With so much stimulus, these artists can easily become overwhelmed. But they find a way to push past the fear of rejection in order to write, create, make, or bring all those inner ideas to life. For them, the act of creating is a necessity of life. Without such an outlet, the artist can dry up or, worse, go mad. And as the artist creates, she discovers new life. The act of creation ignites sparks that simultaneously burn away the constraints that previously held them back and light the path ahead.

But because portrait photography is technically challenging, it's easy to be distracted by the camera and forget to notice what's in plain sight. Van Gogh put it this way: "One may have a blazing hearth in one's soul and yet no one ever came to sit by it. Passers-by see only a wisp of smoke from the chimney and continue on their way." The practice of portraiture gives us a reason to search for sparks or even those less noticeable, small wisps of smoke, to walk toward the chimney and take courage to knock on the door. In this way, a portrait session is an opportunity to sit down and be warmed by the blazing hearth of another's truth.

You and I can make progress on this journey of the inner art of portraiture by nurturing a deeper understanding of what it means to make portraits. To see portraiture as more than camerawork, craft, or commerce. Portraiture is art. Embracing the idea that you are an artist is the quickest and most effective way to begin to elevate your game.

The voices in your head, those voices that are full of fear and self-doubt, might say, "How can you call yourself an artist?" or "Your portraits really aren't that good," or "Stop fooling yourself." At least that's what my voices say, and they trap us in a cage of our own making. But these voices have it all wrong. Sometimes we just need the help of a friend to get uncaged or unstuck. Plus, being an artist has less to do with results and more to do with your intent—that is, your intent to live life to the fullest degree. When you live as an artist, you live an amplified and more wonderful life. You see beauty in hidden places. And you discover awe and wonder in everyday life.

Being an artist is not saying, "I know all about it, I've already found it," but always searching, always saying, "I am looking, I am hunting for it, I am deeply involved." And that is a truth we all can embrace.

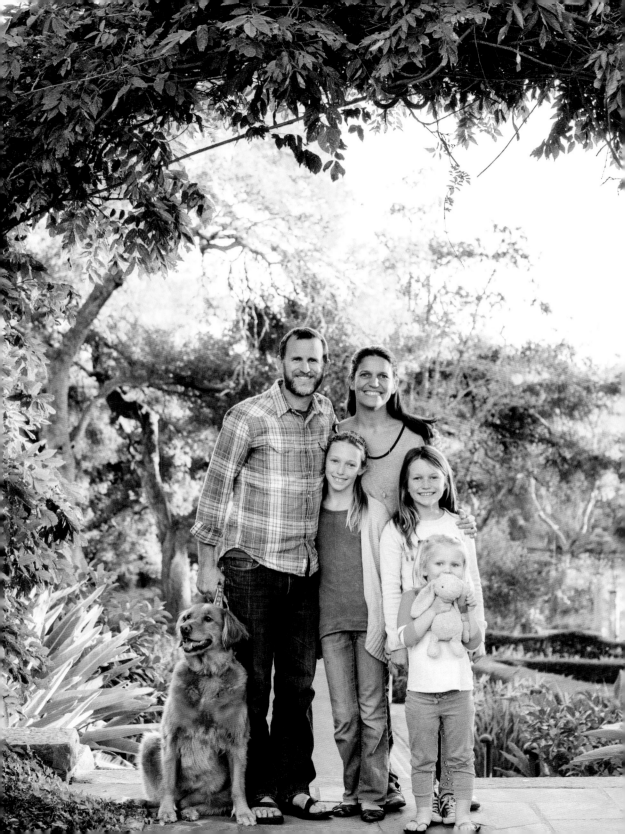

31

GRATITUDE

The sum and substance of all great art is gratitude.

—Amanda Caldwell

It was Memorial Day when I got the call. The sudden sounds of sirens, honking horns, and crying kids was a shock. My wife sounded shaky as she said, "We got in an accident." My whole world stopped. She continued, "Everyone is okay. But get down here as quickly as you can." Adrenaline filled my mind and muscles. I grabbed the car keys and ran out the front door.

The accident happened only a few miles away. I focused all my energy on getting there safely and fast. A mile from the scene, the holiday and accident traffic slowed to a stop. I was stuck. Sitting helplessly, I listened as the sirens wailed, wanting to be close to my family (pictured on the opposite page).

AFTER A LONG WAIT

in traffic I finally arrived and tried to make sense of what I saw—mangled cars, bent metal, broken glass, skid marks, and strange fluids covering the road. Then I saw my wife talking with the police and our three daughters huddled on the side of the road. I rushed in. We all hugged and cried. I had never been so grateful in all my life.

In the ensuing weeks, I couldn't stop thinking about how grateful I was that everyone was okay—the gratitude welled up like an endless freshwater spring, and I felt so alive. Thornton Wilder's words came to mind, "We can only be said to be alive in those moments when our hearts are conscious of our treasures." My heart swelled with appreciation, and I felt blessed. The problems I previously worried about suddenly seemed small. My work problems didn't really matter. The kid's messy rooms weren't so annoying anymore. Their abandoned dirty dishes didn't seem like such a mess. And simply seeing them play in the backyard or watching them sleep soundly in their beds filled my eyes with tears.

EVERYDAY EPIPHANIES

Loss—and maybe even more acute, near loss—makes us appreciate and pay attention to life in a deeper way. John Milton once wrote, "Gratitude bestows reverence, allowing us to encounter everyday epiphanies, those transcendent moments of awe that change forever how we experience life and the world." And this kind of gratitude might be exactly what we need to transform our lives and our photographs from good to great. When we are filled with gratitude, we can't help but create photographs that overflow with awe, wonder, and a deeper understanding of what it means to be alive.

But gratitude doesn't come easy, and it doesn't come without practice and hard work, but that work offers huge benefits. The research has shown that gratitude improves health, happiness, relationships, self-esteem, and so much more. But it's a learned behavior (for most of us, at least) that requires effort and work. If we neglect to practice gratitude, we can easily slip into becoming ungrateful, jaded, and closed off to the magic of the everyday. In doing so, we unknowingly become unaware, and we overlook the wonderful and beautiful things that happen right before our eyes. W. B. Yeats wrote, "The world is full of magic things, patiently waiting for our senses to grow sharper."

As artists who strive to live full and complete lives, we practice gratitude not just to become more confident or happy, but to become more human. We've learned that Yeats was right, and so we practice and cultivate gratitude so that our senses sharpen and come alive. Like how my senses came alive seeing my kids huddled next to our completely ruined car. Of course, experiencing a near tragedy isn't a very reliable (or desirable) way to awaken and sharpen our experience of life. There are other, more pragmatic options. And they all hinge on cultivating gratitude with repeated and regular practice.

Knowing this, I include gratitude as part of a daily ritual and invite you to consider adding more active ways to practice gratitude in your own life. The way I practice gratitude is to say a few words before meals and to write in a journal nearly every day. Each time I journal, I write down three things that I am grateful for. While this sounds simple, I have come to discover that this small act helps me become a better father, husband, photographer, and friend. The practice of gratitude seems to quiet the part of my mind that focuses on the negative and enlivens the part that searches for good.

In a way, practicing gratitude is almost like turning a dial on an old-fashioned radio so that it picks up a station that plays good tunes. Some days the search for an uplifting station is easy while other days it is hard. But each day I keep trying because it helps me to live in a more upbeat way, and it strengthens my resolve to be more creative, make better art, and make the most with what I have no matter what is happening in life.

As a side benefit, after having journaled like this for years, I have filled up multiple journals with lines of gratitude. These lines now serve as a reminder to hope when life gets tough. When I feel down, I flip through the pages and read what I was once grateful for as a way to remember to not give up, to press on.

32
FAQ

Progress is born of doubt and inquiry.

—Robert Ingersoll

Portraiture is a craft that is always changing—just like you. And the more you grow and evolve, the more your portraits will do the same. Unlike some crafts, where mastery is the goal, in portraiture the aim is to continually grow. That's what makes it so challenging and fun.

In addition to study, practice, and introspection, another great way to grow is to pay close attention to the questions that other aspiring photographers ask. These questions often provide insight you could not have found on your own. Hearing another student vocalize a question will sometimes make you realize what you already know, while other times it will make you realize something you had inadvertently overlooked.

THE QUESTIONS my students have asked have taught me a great deal. They have helped me think about portraiture in bigger and broader ways and have made me aware of some of my own habits and techniques. With that in mind, here are a few commonly asked questions that I receive. If this chapter triggers your own questions, don't hesitate to ask. Just visit chrisorwig.com/contact and fill out the form or send me a message on Instagram. I look forward to digging deeper into the questions you have.

HOW MANY PHOTOS DO YOU CAPTURE IN A TYPICAL PORTRAIT SHOOT?

The number of photos I capture in a shoot depends on two factors: my level of interest in the subject, and the amount of time I have. When I photographed the musician Ben Harper (below) I was incredibly excited but I only had 30 seconds, so I captured just three frames. When I have more time, say 30–45 minutes, I'll shoot a few hundred images or more. So you might say that typically I shoot a lot. And because my style is to "find" the photograph rather than set it up, I tend to shoot as a way to discover what I'm looking for. Of course I plan ahead, but I also see the portrait session as a process of discovery and flow.

What I imagine this question is mostly asking, though, is this: "How many photographs should *I* (the question asker) shoot?" And I think it really depends on how you like to work with the subject and work on the computer editing all those frames. Some people like to be concise, clear, and quick as a way to honor the subject's time. Others like to really get to know someone in a calm and kind way. There is no right or wrong answer. But what you have to consider is how much time it will take to process the photos when working in post-production. The more you shoot, the more time you spend on the computer. And sometimes, having a huge chunk of time to edit your photos is a luxury that many of us don't have. So come up with a solution for yourself that considers both the shoot and the post-production time.

If your subject wants to assume some fashion poses, let them do that. It often makes models feel more comfortable to be able to do their thing. Then, transition to a point where you explain that you'd like to create a few photographs that are strong portraits. One line you might use is, "Hey, I want to capture something that is less fashion and more of a portrait... more of something that your brother or best friend would say is an honest portrait of who you are." This can help them to get into the mindset of what you are looking for.

If you shoot fashion but want to add more portraits to your mix, simply take some time to slow yourself and your subject down. And look for those quiet and sincere moments when your subject lets his guard down.

HAVE YOU EVER HAD A PORTRAIT SESSION WHERE YOU TRULY FELT LIKE NONE OF THE PHOTOS WORKED? WHAT DID YOU DO?

I walk away from most of my portrait sessions with high hopes that I captured something good. But sometimes that optimism turns into dread once I import the images into Lightroom and start to review them. I think this happens for two reasons. First, the experience of a portrait session is always better than the raw and unedited frames. Second, during the initial image review it's easy to be overwhelmed by all the photos that didn't work.

What I've learned to do is give myself a few days before I even look at the photos. That way I can distance myself from the experience of the shoot and the actual images themselves. Next, I put on some good music or a podcast as I search for the initial keepers. This initial set includes any halfway decent photos, and I separate those from the rest. Once I've done that I almost always feel better about the shoot. The next step is to go through those photos two more times until I've finished whittling out the keepers from the rest.

But if you go through all the photographs only to realize that none of them are any good, then it's time to step back. Rather than beat yourself up, it's the perfect chance to learn. In my own practice, I ask myself questions like, "Why aren't they any good? Is it something to do with the light, lens, or location? What could I have done differently? Was it something I did 'wrong' or did it have to do with the subject?" Sometimes you'll discover that you made an obvious mistake. Other times, it might have been the result of something out of your control. For me, I've discovered that there are certain portrait subjects that I just don't connect with at all. And that's okay. We are not going to be able to create magic with every person we meet.

WHAT BOOKS DO YOU RECOMMEND FOR BECOMING BETTER AT PORTRAITURE?

My biggest source of portrait inspiration has always come from books, whether it's a book filled with pictures or not. Let's start with the obvious—photography books.

When we view images online, we tend to scroll or scan through them quickly. When we flip through a photography book, we can slow down and really soak up the image. Sometimes I'll even leave a book open on my desk so that I can live with a portrait for a while. For this reason I recommend buying at least a few coffee table books that give you the opportunity to study and enjoy portraiture in printed form. Begin by thinking about photographers you admire and then look into their work. Next, see if you can't find one of their books new or used. To get you started, here are a few books I enjoy: *The Family of Man* by Edward Steichen, *Richard Avedon Portraits*, *Irving Penn Portraits*, *Star Trak* by Anton Corbijn, *Rodney Smith Photographs*, *The Atlas of Beauty* by Mihaela Noroc, *The Road to Seeing* by Dan Winters, *50 Portraits* by Gregory Heisler, *At Work* by Annie Leibovitz, *Portraits* by Steve McCurry.

Looking at photography books isn't the only way to grow. Another option is to read character-based novels, whether they're classics like *The Count of Monte Cristo* by Alexandre Dumas or *The Old Man and the Sea* by Ernest Hemingway, or something more modern. The reason these books can serve as inspiration is because of the way the authors portray the characters without using a single image. These portrayals can help you develop a sense for the inner story of who someone is so that you look past the surface of how someone looks and really get to know who they are.

Another great source of inspiration is to read a biography, whether it's about Theodore Roosevelt, Jack London, or Steve Jobs. Biographies help you think more deeply about how each of us has a story of our own. Because in a sense, as a portrait photographer, it's your job to tell a portion of your subject's story and to do so in an honest and authentic way.

When it comes to learning about how to grow as an artist, I have a list of books that I think every aspiring portrait photographer should read. The list includes: *Wabi-Sabi for Artists, Designers, Poets & Philosophers* by Leonard Koren, *The Letters of Vincent Van Gogh*, *The Art Spirit* by Robert Henri, *Letters to a Young Poet* by Rainer Maria Rilke, *Man's Search for Meaning* by Viktor Frankl, *The War of Art* by Steven Pressfield, *The Shallows* by Nicholas Carr, *The Artist's Way* by Julia Cameron, *Flow* by Mihaly Csikszentmihalyi, *Steal Like an Artist* by Austin Kleon, *Mindset* by Carol Dweck, *The Art of Stillness* by Pico Iyer.

Last but not least, if you really want to grow as a portrait photographer you might want to consider working on your interpersonal skills. I have found the following books to give me an understanding and an edge when it comes to quickly connecting with people. If you decide to read one of these, be sure to read it from the perspective of portrait photography. Always ask yourself, "How can I take what is written and apply this to the craft of photography?" Here are my top recommendations and must-reads for any portrait photographer: *What Every Body Is Saying* by Joe Navarro (or any of Joe's books—they are all great), *How to Win Friends & Influence People* by Dale Carnegie, *The Charisma Myth* by Olivia Fox Cabane, *Captivate* by Vanessa Van Edwards, *How to Talk to Anyone* by Leil Lowndes.

33

THE JOURNEY AHEAD

Tell me, what is it that you plan to do
with your one wild and precious life?

—Mary Oliver

The aim of this book has been to expand the way we think about and practice the craft of portraiture. Also woven throughout the book is the idea that who we are directly and deeply affects what we create. My hope is that this has led to the realization that getting good at portraiture isn't just learning new techniques but searching within ourselves. This book is about the mixture of photography, self-growth, and self-determination because the three are inextricably intertwined.

GETTING BETTER at portraiture hinges on learning some basic photographic skills, developing a strong sense of self-awareness, and having a distinct plan. Otherwise, we risk walking down the photographic path without any sense of where or why. And the path to creating authentic and meaningful photographs can't be found without first discovering our own true north.

I mention all of this because now is the time to think about the path ahead. And the best way to move forward is to first take some time to reflect back on what you've learned. For without a clear understanding of the past, it's difficult to know where you need to go next.

WHY I WROTE THIS BOOK

By way of example, my own journey in writing this book has been an unexpected one. At first, when I set out to start writing I suddenly realized I wasn't ready. I instantly knew that there was more I needed to learn before I could begin. I had no idea what I needed to learn, but I knew that if I started the project too early, I would miss the point. Because, for me, the point of writing a book has never been to share what I've learned in the past, but to share how I'm growing right now.

At the time, I was in a rut and I knew this rut (like most ruts) was really me on the brink of learning something new. I knew I needed to stay in the rut and work through it rather than run and hide. With the approval of my editor, we put the project off for a year because the timing wasn't right.

The reason I share this is to emphasize that all creative growth is anchored in time. Let me illustrate this idea with another example. If you were to see the *Mona Lisa* at age 16, you might say, "Wow, it's really small." If, at age 22, you took an art class and studied the painting, you might say, "What a fascinating piece." And if you revisited the Louvre at age 60, you might look at the painting and simply weep. Even though nothing about the painting changed, your experience of it was shaped by the passage of time.

I like how Ralph Waldo Emerson put it: "The years teach much which the days never know." With each passing year, you learn new things, or perhaps more accurately, you are ready to learn new things.

For some reason, the universe led me to try to write this book during that particular year because it knew I was ready for a breakthrough. Granted, I had no idea what that breakthrough would be, but I knew something surprising lay ahead.

With all that in mind, it's worth sitting down and writing out a response to the question, "Why was I led to read this book at this particular time?" Similarly, I asked myself, "Why was I led to write this book right now?" Here's my response: I think I was led to write the book because I was in need of an authentic transformation myself.

For the majority of my life, I have lived with deep and hidden self-rejection. From an outsider's perspective it looked like I was confident and strong. But within, I feared rejection. I wrongly thought that if you truly knew who I was, you wouldn't like me. And since you wouldn't like me, I rejected myself. All of this took place beneath the surface, hidden from plain view. From the outside, everything looked great, but on the inside

I felt rejected and hurt. And it was from this hurt that I searched for a solution. Part of that solution was trying to get people to like me. Another part was striving and searching for authenticity wherever I could find it. I wanted to get to know authentic people because the realness they possessed was missing from my life. I wanted to learn to be like them. I wanted to learn how they let go of the worries of the world, which would help me become a truer version of myself.

Through self-reflection, therapy, meditation, and then writing this book, I'm happy to share that I have grown and changed. And the change has been a miraculous one. Somewhere along the way, something shifted. Now, rather than seeing a dark pit in the deepest core of who I am, I see light. And I feel more authentic, real, and alive. So the short answer to the question, "Why was I led to write this book right now?" is this: so that I could heal.

Of course, this is my story. I share it to illustrate again that all creative growth is anchored in time. And the way we grow the most is to take the time to reflect and realize how we've changed.

YOUR JOURNEY

So I encourage you to think about why you read this book. What was the point? Maybe it has nothing to do with the lessons I was trying to teach. Maybe those lessons acted as a key to unlock something much bigger and better than what this book provides. That would be wonderful because, to me, the best books always light a fire and illuminate the way.

After having reflected on what you might be learning right now, the next questions to ask are, "What does the universe want for me next? Is there some area of personal growth that has come to mind? Is there an area of technical expertise I need to master next? Is there some specific way I need to put into practice something I've learned?"

Whatever it is, it's time to act—that's the whole point of this book. And as I mentioned earlier, Henry David Thoreau put it best: "A truly good book teaches me better than to read it. I must soon lay it down, and commence living on its hint. What I began by reading, I must finish by acting."

My biggest hope is that this book has been a source of insight and inspiration. I also hope that we can keep in touch. I see this book as a soul-to-soul conversation between two friends, and I hope that we can keep this friendship alive. I know I'm better off with a community rather than alone. So I'd love to hear from you and continue the conversation. You can reach me through my website (chrisorwig.com) or follow me on Instagram (@chrisorwig) and we can message that way. Either way, it would be wonderful to hear from you.

Finally, now is the time to get out there and finish what we started by taking your own action to make the lessons learned come to life.

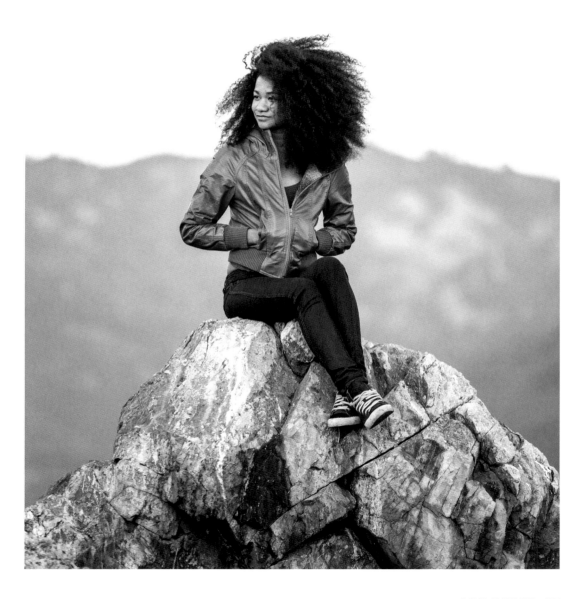

THANKS

Thanks to my wife Kelly for your constant encouragement and belief in who I am and who I am becoming. I am grateful beyond words to share life with you.

Thanks to my daughter Annie for reminding me how to create photographs that aren't so stiff and for showing me how to live in such an exuberant way.

Thanks to my daughter Sophia for always having my best interest in mind. Your kind and warm heart is like sunshine to my soul.

Thanks to my daughter Elsie for your huge hugs and constant love. Your creative and adventurous spirit brings us all so much joy.

Thanks to Ted Waitt for your tireless efforts and collaboration on this project. You are one of my most valued friends.

Thanks to Scott Cowlin for your friendship, support, and vision. I appreciate your down-to-earth and real approach to life, work, and creativity.

Thanks to Owen Wolfson for executing the design of this book in such an elegant and fabulous way.

Thanks to Kayla Lindquist for inviting me to be a part of the Sony team. You have helped me grow in unimaginable ways. Being a part of the Sony family has been one of the top highlights of my career. Thank you.

Thanks to Matt Parnell for building such an amazing photographic family and team at Sony. Your vision and support have catapulted us all to new heights.

A *huge* thanks to Stewart Caldwell. Your creative spirit and inventive ideas are inspiring! I look forward to many more adventures in the future.

Thanks to the following friends, colleagues, mentors, and luminaries who constantly inspire and challenge me to become a better version of myself: Martyn Hoffman, Greg Lawler, Mike Collard, Mitch Thomas, Nate Rogers, Andy Eubank, Maury Hayashida, Mom, Dad, Dane Sanders, Mike Coots, Chris Burkard, Chris Lieto, Ben Moon, Jeff Johnson, Joe Curren, Daniel Milnor, Paul Dektor, Peter Burke, Miguel Quiles, Bruce Heavin, Lynda Weinman, Matt Kloskowski, Mike Burke, Brian Smith, Katrin Eismann, Julieanne Kost, Keith Carter, Jonas Jungblut, Caroline Jensen, Pei Ketron, Erik Almas, Steven Tiller, Jim Appleton, John Kelsey, John Paul Caponigro, Sarah Thomas, Ryan Caldwell, Cara St. Hilaire, Whitney Chamberlin, Gar Ryness, Geoff Burke, Glen Phillips, Tony Mac, Amanda Caldwell, Amber O'Neill, Cathy Cousart, Jose Mendez, Mark Seliger, Jeff Shelton, Travis Blue, Todd Glaser, Will Wallin, Aaron Kowalczyk, and Jeff Nelson.

IMAGE DETAILS

Throughout the book I have intentionally not included the camera settings for photographs because I did not want the focus to be on the mechanics of how the images were made, but instead on the internal process of who we are and how that affects what we create. That said, I do find it interesting to learn about how images are made and about the camera settings that other photographers use. So with that in mind, here are the settings for each chapter's opening image. As you'll see, my camera settings don't change very much, and therein lies one of my most valuable techniques—keeping it simple so that the camera doesn't get in the way.

Chapter 01: Sony A7R III, 85mm, f/1.4, 1/320, ISO 160. A portrait of Phil Sullivan on the streets of Red Hook, New York. Here Phil sits on the steps of an old building, relaxed and in his element.

Chapter 02: Sony A7R III, 85mm, f/2, 1/1250, ISO 400. It was in the middle of the day and the sun was harsh. While walking by an old building I asked Ashley to step into the shade and lean against the wall. The soft and almost glowing light helped to draw out her vibrant and wonderful spirit.

Chapter 03: Sony A9, 85mm, f/3.2, 1/4000, ISO 640. While waiting for my subject to show up for a shoot in San Francisco, I noticed this guy as he walked by. I struck up a conversation and asked if I could capture his portrait. The background in the first image wasn't any good so I asked if he would turn and face the sea.

Chapter 04: Canon 5D III, 85mm, f/1.8, 1/800, ISO 800. A portrait of Yvon Chouinard in his blacksmith shed in Ventura, California.

Chapter 05: Canon 5D III, 50mm, f/3.2, 1/500, ISO 300. A portrait of Jack O'Neill sitting on his porch overlooking the Pacific Ocean in Santa Cruz, California.

Chapter 06: Canon 5D III, 85mm, f/2, 1/800, ISO 320. Rob Machado photographed at the Channel Islands surfboard factory in Carpinteria, California.

Chapter 07: Sony A7R II, 50mm, f/1.4, 1/5000, ISO 125. While on assignment to photograph the philanthropist and dancer Janet Reinick, we went to Butterfly Beach in Santa Barbara. Knowing she was a dancer, I asked her if she would be up for dancing. She literally leapt at the opportunity. It was wonderful to see someone at a retirement age so nimble and graceful.

Chapter 08: Sony A7R III, 85mm, f/1.4, 1/1000, ISO 160. A portrait of the Broadway performer Bryce Ryness during a workshop in Los Angeles.

Chapter 09: Sony A7R III, 85mm, f/3.5, 1/50, ISO 250. This portrait of Jeff Johnson was captured in an unlikely way. We had just finished shooting some photos for one of his sponsors and I mentioned I'd like to grab a portrait as well. With the commercial work finished, we walked toward his garage and talked. Jeff stood at the opening of his garage and looked out toward the light while holding a black piece of foam core behind his back. During a pause in the conversation, I made this portrait.

Chapter 10: Sony A7R III, 85mm, f/1.4, 1/1000, ISO 320. A portrait captured at the opening of a parking garage in downtown Los Angeles. By having the subject stand in the shade, it created soft light during the middle of the day.

Chapter 11: Sony A7R III, 85mm, f/1.6, 1/6000, ISO 160. The actress Isabel Lucas captured in front of a hand-dyed indigo background in Topanga Canyon, California.

Chapter 12: Sony A9, 85mm, f/1.4, 1/1600, ISO 200. Sometimes a test shoot can lead to great results. This portrait of Hannah was captured while scouting a location for an upcoming workshop.

Chapter 13: Sony A7R III, 85mm, f/1.4, 1/400, ISO 320. A natural-light portrait of Davey King captured in the lobby of the Javits Center in New York City.

Chapter 14: Sony A7R III, 85mm, f/1.4, 1/1000, ISO 200. An open-shade portrait of Caterina captured in front of a rustic red door in Santa Barbara, California.

Chapter 15: Sony A9, 85mm, f/1.6, 1/1000, ISO 200. While attending a workshop, I had a chance to photograph Karina Dobra. The location was an ugly industrial parking lot. Yet by asking the subject to stand with her back to the sun, and using a shallow depth of field, I was able to create an interesting portrait in an otherwise uninteresting location.

Chapter 16: Sony A7R III, 85mm, f/7.1, 1/16000, ISO 800. Just as the sun rose, I changed my exposure settings in order to create a silhouette of a friend holding his surfboard.

Chapter 17: Sony A7R III, 85mm, f/1.4, 1/320, ISO 500. A window-light portrait of Heather in New York City.

Chapter 18: Canon 5D III, 85mm, f/2.5, 1/160, ISO 320. Danny Hess is best known for the surfboards that he shapes. This portrait was captured at the entrance to his workshop in San Francisco, California.

Chapter 19: Canon 5D III, 85mm, f/3.5, 1/200, ISO 320. Johnny has the best beard of anyone I have ever seen in my hometown of Santa Barbara. So I reached out and set up a time to capture a few portraits. This one was captured in front of a giant painting located next to a window in a small boutique shop.

Chapter 20: Sony A7R III, 85mm, f/1.8, 1/250, ISO 320. While at a busy and noisy photography event in New York, I found a moment to introduce myself and then capture this quiet and strong portrait.

Chapter 21: Sony A7R III, 85mm, f/1.4, 1/800, ISO 100. A portrait of Ben Moon standing in a busy kitchen's doorway, facing the light. I used a piece of white foam board to block out the background and create soft and wrapping light.

Chapter 22: Canon 5D III, 50mm, f/2.2, 1/1250, ISO 400. A slightly overcast day created the perfect light to capture Leo Basica along the Big Sur coast in California.

Chapter 23: Sony A7R II, 85mm, f/1.8, 1/200, ISO 200. A backyard portrait of Nico.

Chapter 24: Sony A7R III, 85mm, f/2, 1/250, ISO 320. With a name like Zen Ocean, I knew I needed to capture a portrait that wasn't run of the mill. So I asked Zen to stand in front of an old blue wall and really paid attention to the light in his eyes. Once I found the right spot, I captured this frame.

Chapter 25: Sony A7R III, 85mm, f/1.4, 1/500, ISO 320. Briefly meeting Tom made me realize he was a deep and soulful man. But when I heard about all the work he had done with hospice, it really helped me to get a sense of who he was. This portrait was captured while Tom sat sideways on a chair as doorway light came in from the left.

Chapter 26: Sony A7R III, 85mm, f/1.4, 1/160, ISO 400. A portrait of Arna Bajraktarevic in Santa Barbara, California.

Chapter 27: Sony A7R III, 85mm, f/2.8, 1/200, ISO 400. A portrait of Madison Keesler along the ocean's edge in San Francisco.

Chapter 28: Canon 5D III, 50mm, f/2.2, 1/1250, ISO 400. A slightly overcast day created the perfect light to capture Isabel Lucas along the coast in Santa Barbara, California.

Chapter 29: Sony A7R III, 85mm, f/2, 1/160, ISO 400. A portrait of Rick Elder in downtown Los Angeles.

Chapter 30: Sony A7R III, 85mm, f/1.4, 1/125, ISO 200. Chris Burkard is one of the most inspiring and impressive people I have ever met. Yet, in spite of all his accomplishments, somehow he has the ability to put people at ease. I captured this portrait in his garage as he faced the open door.

Chapter 31: A portrait of my family by friend and photographer Cara Robbins.

Chapter 32: Canon 5D III, 50mm, f/2.8, 1/500, ISO 200. Madeline Ostroski looking toward the light in Santa Barbara, California.

Chapter 33: Sony A7R III, 135mm, f/1.8, 1/400, ISO 400. A portrait of Jason Bell captured in downtown Hollywood, California.

INDEX